The Campus History Series

FURMAN
UNIVERSITY

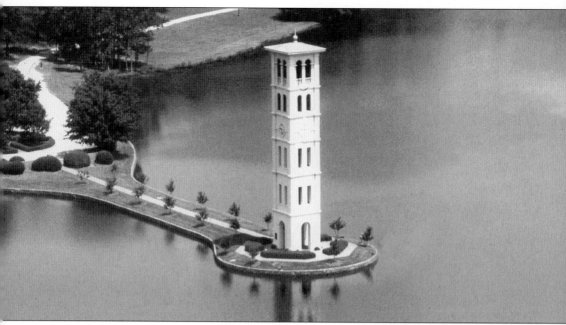

Originally built on Furman's downtown campus in 1854, the Bell Tower is the most enduring symbol of Furman University, and stories regarding its historic place in Furman's campus culture abound. The bells rang after Confederate victories during the Civil War, and, beginning in the 1890s, after major football or basketball wins. The bells rang all night, for instance, the evening that Furman's Frank Selvy led the basketball team to a win over New York University in Madison Square Garden in the 1950s. In 1924, Class President "Brick" Brasington played a practical joke by guiding a cow up to the top of the tower before a big game against Clemson, only to discover that he couldn't guide it back down. Furman lore warns that the person you kiss under the Bell Tower will be your last.

When Furman moved to the new campus, the Bell Tower was not in stable enough condition to be moved. On his own initiative, Carl Clawson, director of physical planning and construction, climbed the tower and measured every detail. Plans to construct a smaller, 55-foot replica near the planned rose garden met with opposition from Clawson, who envisioned the tower on a small peninsula on the lake, where its full height could be seen.

Through a contribution from the children of Alester Garden Furman in honor of their father, the new Bell Tower was built with the exact specifications from the old. At 88 feet 1 inch tall and 14 by 14 feet square, the Bell Tower stands within one-sixteenth of an inch of the original. Furman contacted Van Bergen, the same company that created and installed the carillon on The Citadel's campus, among many others. When asked how many bells he wanted the carillon to have, President Plyler inquired as to how many bells The Citadel had. Upon learning that The Citadel had 59 bells in its carillon, he fueled the institutions' longtime rivalry by promptly ordering 60 for Furman's tower. Friend and family of John Edward Burnside '17, the first chair of Furman's Advisory Council, honored him with the purchase of the 60-bell carillon.

A 2004–2005 campaign enabled the restoration of the Bell Tower and carillon.

Cover Photo: The Furman faculty were photographed in 1887. They are, from left to right, (first row) math professor and administrator Charles Hallette Judson, President Charles Manly, and former president James C. Furman; (middle row) classics professor Harvey Toliver Cook and chemistry professor William Franklin Watson; (back row) Assistants Henry Hitt Watkins and W.M. Clyde.

The Campus History Series

FURMAN UNIVERSITY

COURTNEY L. TOLLISON, PH.D.
FOREWORD BY PRESIDENT DAVID E. SHI

ARCADIA

Published by Arcadia Publishing
Charleston SC, Chicago IL, Portsmouth NH, San Francisco CA

Printed in Great Britain

Library of Congress Catalog Card Number: 2004111304

For all general information contact Arcadia Publishing at:
Telephone 843-853-2070
Fax 843-853-0044
E-mail sales@arcadiapublishing.com
For customer service and orders:
Toll-Free 1-888-313-2665
Visit us on the internet at http://www.arcadiapublishing.com

ACKNOWLEDGMENTS

Behind the camera lens, we are all historians, producing mechanical images that capture and preserve time. Black-and-white photography in particular prompts a unique psychological experience: the mind registers a lack of color as "old." Many photographs in this publication feature buildings that no longer stand and people who are no longer with us. They are intended to remind readers of the university's rich heritage.

The support among Furman administrators, faculty, and staff has been gratifying. I thank President David E. Shi for his interest in and support of this project. President Shi, Former Vice President A.V. Huff, Vice President Donald Lineback, and Carol Daniels read drafts of chapters and provided welcome suggestions.

Carolyn Lancaster and Melissa May Bateman in University Archives and Charlie Register and Jim Stewart in Public Relations and Marketing guided me through their collections and tolerated my many requests. I am grateful for their assistance, and I hope they will take pride in this work, as it is so much a reflection of their contributions.

Janis Bandelin, Nancy Cooper, Dr. Glen Halva-Neubauer, DebbiLee Landi, Capt. Shea Sherbert, Dr. Harry Shucker, Dr. Susan Shi, Tom Triplitt, and Benny Walker have assisted me in myriad ways. Furman graduates Courtney Armstrong Buxton, Ansley Campbell, and Elizabeth Herre, and current student Johanna O'Brien offered terrific photographs from their student days.

Many individuals unassociated with Furman graciously contributed as well. I thank Ellen Tollison Hayden, Joe and Doug Jordan at Joe Jordan Photography in Greenville, and Sydney Yarborough at the Greenville County Historical Society. In addition, Jane Poster at the South Carolina Baptist Student Union (BSU) Archives in Columbia, South Carolina, generously donated a photo of Joe Vaughn and fellow BSU officers.

Editor Barbie Langston of Arcadia Publishing has been enthusiastic, patient, and a pleasure with whom to work. I also thank Laura Daniels New of Arcadia for her early interest in this project and Katie White of Arcadia for her excellent editorial assistance. Finally, I'm grateful to my parents, who strategically instilled in me a love for Furman long before I moved into Gambrell 200! Their boundless support astounds and inspires me.

Unless otherwise noted, photographs are from the University Archives Division of the Special Collections in the James B. Duke Library, Furman University.

CONTENTS

FOREWORD

Furman is a place with majestic branches and deep roots. In this illustrated history of the university, Courtney Tollison tells the story of Furman's courageous development over nearly two centuries.

Just as the course of a river is carved out and given form by all that has moved through it, so Furman is a product of many shaping events and people, a place near and dear to us, but reforming itself each day.

The campus is an imaginative location as well as a physical setting. The buildings, trees, fountains, walkways, and lake have a remarkable power to evoke time and place, to dislodge memories of characters who graced this campus, and to resurrect stories of relationships that remain timeless in their significance.

Those who come here to learn are changed in the process, and the subjects they study change, and the clothes they wear and the buildings they inhabit change. Yet all the time it remains Furman University—a place, a loyalty, an ideal, a distinctive way of thinking, behaving, and learning.

In the midst of new buildings and arenas and playing fields, Furman remains a place filled with remarkable people motivated by high ideals and demanding standards, a learning community inspired by a palpable spiritual power. It remains a place where students develop a profound sense of belonging to a community of learners and seekers, an unpretentious place where young people can grow and express themselves freely, where people know and care about each other and are known and cared for by them, a place where students are persons rather than numbers.

The following pages help remind us that a college is not merely a place or a course of study; it is a life-changing experience that endows us with a perpetual sense of belonging.

David E. Shi
President

6

INTRODUCTION

Throughout its history, Furman University has operated under three names, resided in five different locations, embraced coeducation and integration, and dissociated from the organization that conceived it. Its institutional history has been marked by stern challenges and remarkable rejuvenation, and it has been anchored by deeply rooted consistencies.

As founder and president of the South Carolina Baptist Convention, Dr. Richard Furman identified the education of ministers as his priority during the early 1820's, and he strove to perpetuate the vision of his mentor, Oliver Hart, who established an education fund for young ministers in 1751. Richard Furman encouraged the development of Columbian College, now George Washington University, in the nation's new capital in 1821, and he hoped to establish an academy in South Carolina. Between 1823 and 1826, Baptist leaders established the foundation for such an institution. In 1826, the South Carolina legislature chartered the Furman Academy and Theological Institution, which held its first classes on January 15, 1827, in Edgefield, South Carolina.

Twenty-four years later, Furman remained in an embryonic state. The academy and institution had changed locations twice, and halted classes for extended periods of time because of financial hardship. Hope came, however, in the promise of yet another move. In 1850, the South Carolina Baptist Convention (SCBC) decided to relocate Furman from Winnsboro to Greenville. The upstate climate was milder than the Midlands, the village was experiencing rapid growth, with promises of a railroad in the near future, and Baptists had already established girls' and boys' academies there in 1820.

The move to Greenville sparked a series of developments. In 1850, the academy was rechartered as "The Furman University," and the college department opened in February 1852. The trustees hoped that Furman would one day support a seminary, as well as law and medical schools. In 1854, its first permanent building, with its Florentine Bell Tower, was completed near the Reedy River, and South Carolina Baptists established the Greenville Baptist Female College after its boys' and girls' academies closed. Five years later, the Southern Baptist Convention (SBC) decided to develop a seminary associated with Furman in Greenville, and many of the college's most talented faculty transferred their appointments to the seminary. James C. Furman, son of Richard Furman, remained behind, and in 1859 became the first president of The Furman University.

During the Civil War and subsequent Reconstruction, however, Furman and the Greenville Female College (GFC), as it had become known, struggled. Furman closed, as most of its students joined Confederate units. In 1866, Furman reopened, operating simply as "Furman University." The board of trustees, which also governed the GFC, sold much of the female college's land to alleviate debt, and in 1879, the SBC transferred its seminary to

7

Louisville, Kentucky. During the 1880s and 1890s, however, Greenville's textile mills spurred quick development as a "New South" city even before that phrase became fashionable. Furman benefited from Greenville's economic development.

Presidents Charles Manly and Andrew Philip Montague guided Furman into economic stability near the turn of the century. Manly supported coeducation, a first, and with Montague's approval of a new dormitory named after his mother, Furman became a residential campus for the first time since 1850. Intercollegiate athletics began at Furman in 1889, and Mary C. Judson embarked on a career at GFC that spanned four decades.

In 1908, the GFC developed its own board of trustees, and in 1916 changed its name to Greenville Woman's College. Furman established a law school in 1921, and in 1924, the Duke Endowment named Furman an annual beneficiary, along with Davidson College, Johnson C. Smith University, and Trinity College, now Duke University. Alumnus William Blackburn '21 was awarded a Rhodes Scholarship, Furman won official accreditation, and in 1926, celebrated the centennial year of its founding.

The Great Depression initiated a prolonged financial crisis. In 1933, Furman trustees assumed control of the floundering GWC, and in 1938, the two colleges formally merged. The women of the Greenville Woman's College of Furman University and the men of Furman rode buses between the "zoo" and the "hill" for over two decades.

As early as the 1920s, anxiety regarding the lack of space for campus expansion began to concern trustees and administrators, as the city of Greenville had developed around the campus boundaries. In the late 1940s, trustees J. Dean Crain and Alester G. Furman Jr. championed the development of a new campus. In 1947, a committee of trustees explored five options for a new site. In 1950, President and Mrs. John Plyler and several trustees examined property several miles north of town, near Duncan Chapel Road. The group parked their cars near the property's highest point, and, with Paris Mountain serving as a backdrop, surveyed the landscape. Soon thereafter, trustees purchased 1,000 acres of cotton fields and pastures, and formally broke ground for a majestic new campus in 1953. For the first time in its history, Furman University became fully coeducational in 1961.

In the mid-1960s, President Gordon Blackwell ushered in a new era for the university with his aggressive pursuit of "excellence by national standards." Highlights of his administration include desegregation, the inauguration of intercollegiate athletics for women, and the installation of a Phi Beta Kappa chapter. Increasingly, however, academic excellence became incompatible with the SCBC's increasing fundamentalism, and under President John E. Johns, Furman dissociated from the SCBC in 1992. Since that time, the endowment has more than doubled as a result of generous bequests from Mrs. Homozel Mickel Daniel and other major donors, and extraordinary alumni participation in giving; Furman ranks among the top ten larger universities nationally in its percentage of alumni contributing. The success of Furman athletics, coupled with the renovation and expansion of campus facilities and the increasing focus on "engaged learning" under President David E. Shi's leadership, have raised the university's visibility and stature.

Throughout its history, Furman has renewed and recast its institutional identity. No longer a regional Baptist institution, Furman has earned its rank among the best liberal arts colleges in the country. The magisterial bequest of John D. Hollingsworth in 2001 promises to enhance greatly Furman's financial foundation.

Throughout its journey, Furman has retained its intimacy, generosity of spirit, and commitment to educating the whole person. Furman is an institution that cherishes what it has been, yet anticipates its future with excitement as the university begins to fulfill its potential as a leading institution of higher learning.

"Then rally, sons and daughters true; 'Round our dear Alma Mater"
Dr. E.M. Poteat

One

FURMAN ACADEMY AND THEOLOGICAL INSTITUTION

1826–1850

Soon after Dr. Richard Furman founded the South Carolina Baptist Convention, the nation's first Baptist statewide denominational body, Furman proposed the establishment of a regional academy to educate and train ministers in the Baptist faith. On December 2, 1823, South Carolina Baptist leaders met with two representatives from Georgia to discuss the feasibility of an educational institution located in South Carolina that could be supported by both Georgia and South Carolina Baptists.

Subsequently, incoming South Carolina Baptist Convention (SCBC) President W.B. Johnson led efforts to petition state legislators for a charter for the newly conceived institution. Responding positively, on December 20, 1825, the South Carolina legislature incorporated an "academical and theological seminary for the education of youth, generally, and of indigent pious young men, particularly, who may be designed for the gospel ministry."

A board of Baptist convention leaders unanimously elected Joseph Andrew Warne the first principal of the promising new institution on September 18, 1826. Three months later, the board reconvened and established a set of laws for the institution, and on December 19, 1826, the name "The Furman Academy and Theological Institution" appeared for the first time in honor of the life and contributions of Richard Furman, who had died on August 25, 1825.

The academy and institution was to be "under the general direction of the state convention of the Baptist denomination in South Carolina; who alone shall have the power to alter or amend the rules." With ten eager and brave students, the Furman Academic and Theological Institution began the first classes in Edgefield, South Carolina, on January 15, 1827.

Convention leaders selected Edgefield, South Carolina, as the academy's location because the Edgefield Village Academy deeded its building and property to the SCBC. Edgefield's proximity to the Georgia border was also attractive; South Carolina Baptists hoped that the proximity would encourage a joint venture with Georgia Baptists. Georgia Baptists soon established an institution of their own, however, named for the well-regarded Georgia Baptist Jesse Mercer, who had participated in the 1823 discussion regarding a possible joint venture with South Carolina Baptists.

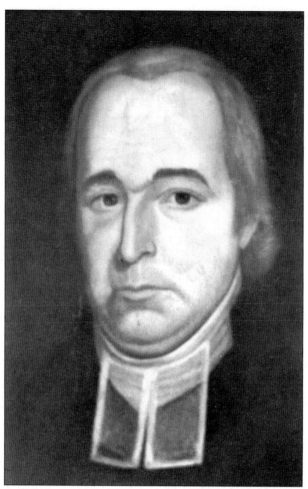

Born in Esopus, New York, in 1755, Richard Furman moved with his family to Charleston, South Carolina, when he was a child, and then to the High Hills of Santee, near present-day Sumter, South Carolina. Prominent Baptist minister Joseph Reese greatly influenced Furman, and he converted from Anglicanism to the Baptist faith. Furman was ordained at 19 and quickly developed into a political and spiritual influence in the state. During the Revolutionary War, Furman volunteered to fight, but the President of the Provincial Congress of South Carolina, John Rutledge, felt Furman's presence in the upstate could more effectively persuade loyalists in the area to support the patriot cause. According to lore, British Commander Lord Charles Cornwallis noted Furman's success and thus placed a price of 1,000 pounds on Furman's head. In 1778, Furman was among a group that effectively petitioned the legislature to disestablish the Church of England in the state, and in 1790, he served as a delegate at the South Carolina Constitutional Convention. Furman served as pastor of the First Baptist Church in Charleston from 1787 until his death. Rhode Island College (Brown University) granted him an M.A. in 1792 and a Doctor of Divinity in 1800. In 1814 and 1817, delegates at the Triennial Convention, the first national gatherings of Baptists in this country, elected Furman president. Richard Furman founded the first statewide Baptist organization in the country, the South Carolina Baptist Convention, and served as its first president from 1821 to 1825. Furman's emphasis on education inspired the founding of Columbian College (now George Washington University), Furman University, Southern Baptist Theological Seminary, and Mercer University.

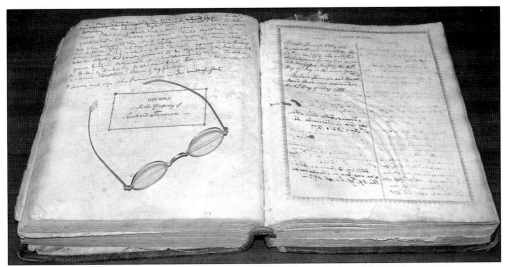

The Furman University Archives has Richard Furman's spectacles and family Bible, shown above, and his pulpit robe. "Richard Furman" is legible in the inscription box. The right page records his marriage to Elizabeth Haynsworth in November 1774, the same year in which he was ordained. After his first wife's death, Furman married Dorothea Burn in May 1789; his two marriages produced 17 children. Furman died in Charleston on August 25, 1825, and is buried in First Baptist Church, Charleston.

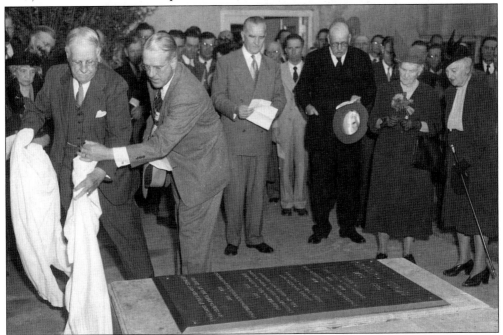

Relatives of Richard Furman, for whom the university is named, unveil a grave marker in the First Baptist Church, Charleston, in November 1950. From left to right are Alester G. Furman, great-grandson of Richard Furman; Alester G. Furman Jr., great-great-grandson of Furman; President John L. Plyler; Trustee J. Dean Crain; Mrs. Constance Furman Herbert, great-granddaughter of Furman; and Mrs. Annis Furman Pendleton, great-granddaughter of Furman.

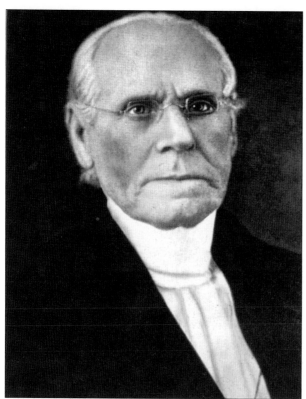

A protégé of Richard Furman, William Bullein Johnson (1782–1862) served as the first president of the Southern Baptist Convention (SBC). In the closing months of 1825, Johnson led efforts to convince the South Carolina State Legislature to incorporate an education institution, the soon to be named Furman Academy and Theological Institution. Johnson served as the first principal of the Female Academy in Greenville, chairman of the board for the developing Furman Academy, and chancellor of the Baptist-affiliated Johnson Female Seminary in Anderson, South Carolina. W.B. Johnson is buried in the churchyard of First Baptist Church, Anderson.

This is a pen sketch of the academy's original building in Edgefield, where classes for the newly established Furman Academy and Theological Institution began on January 15, 1827. In 1963, Don Sanders copied this sketch from William J. McGlothlin's *Baptist Beginnings in Education*.

Basil Manly Sr. (1798–1868) assumed the pastorate of First Baptist Church in Charleston after Richard Furman's death and contributed significantly to the establishment of an educational institution to honor Richard Furman. Manly, a North Carolina native, graduated from South Carolina College (USC) in 1821. Manly moved to Charleston in 1826 from Edgefield; when he moved, Furman purchased his home and property for use as the principal's residence. In 1837, Manly resigned from First Baptist Church to become president of the University of Alabama in Tuscaloosa; after his resignation in 1855, Manly presided over a committee of Baptists who endorsed a seminary for the education of Baptist ministers, the future Southern Baptist Theological Seminary. In 1861, Manly gave the prayer at the inauguration ceremonies for Confederate President Jefferson Davis in Montgomery, Alabama. His sons Basil Jr. and Charles also devoted their energies to education and the Baptist faith.

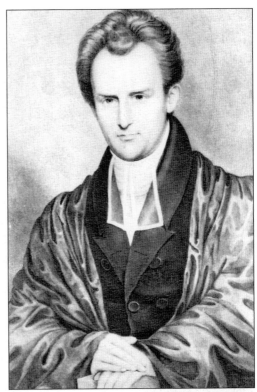

The 96th district chapter of the Daughters of the American Revolution placed this historical marker on the original site of Furman Academy and Theological Institution in Edgefield on March 17, 1926.

This obelisk is a monument to John Mitchell Roberts, who operated Roberts Academy from 1800 to 1810 in his home in the High Hills of Santee. He donated his theological library to the new Furman Academy and Theological Institution.

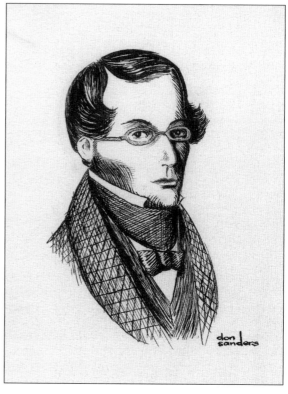

Joseph Andrew Warne (1795–1881), unanimously elected to be the first principal of the institution on September 18, 1826, was Furman's first and only instructor when the academy began its classes on January 15, 1827, in Edgefield. Warne nurtured the infant academy but, overwhelmed by the responsibilities, left after one year and a half, still the academy's only professor. He was succeeded by W.D. Cowdrey, who stayed only six months, and then Jesse Hartwell. In 1964, Don Sanders sketched this from a steel engraving in the frontispiece of *A Companion to the Bible*, edited by William Jenkes.

In 1828, Furman had only three ministerial students; its future was tenuous. Jesse Hartwell, minister at the High Hills of the Santee in Stateburg, salvaged the institution when he took students into his home in 1829 and served as the sole instructor. When enrollment increased, Hartwell built two cabins for the eight students with his personal funds. Furman remained in Stateburg from 1829 to 1834. During this time, Furman dedicated its mission solely to the education of ministers. Hence, Furman changed its name to the "Furman Theological Institution." In 1834, the state Baptist convention amended Furman's constitution so as to allow for the existence of a board of trustees. The first trustees included James C. Furman, Basil Manly Sr., and Nicholas Ware Hodges. This photograph shows the historical marker in the High Hills of the Santee.

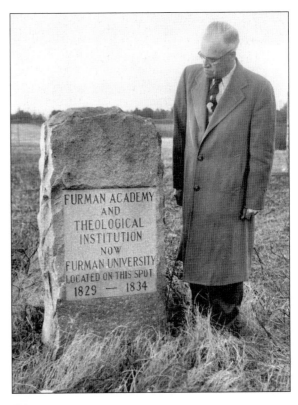

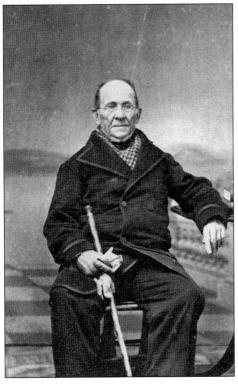

The son of Richard Furman and Dorothea Burn, Samuel Furman assumed some of the teaching responsibilities from Jesse Hartwell in 1830. The state Baptist convention sent Furman to relieve some of Hartwell's load, but did not pay either man; both men resigned exhausted in December 1834. Institutional stability had not improved in Stateburg, and thus Furman did not conduct classes in 1835–1836. Baptist leaders, led by Nicholas Ware Hodges, began intense fund-raising efforts to salvage the institution.

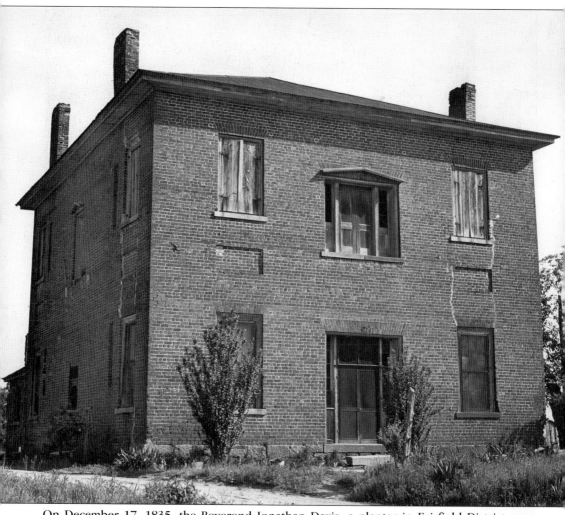

On December 17, 1835, the Reverend Jonathan Davis, a planter in Fairfield District, was elected chair of Furman's board of trustees. Davis immediately began looking for a new location to resume institutional operations. Within the next several weeks, Davis wrote to his son-in-law, James Clement Furman, describing 600 fertile acres near the Baptist church in Winnsboro, Fairfield District. On March 8, 1836, Davis bought 557 acres from Jesse Nelson for $7,400. Furman erected a 12-foot-long and 30-40–foot-wide frame building that provided housing, a library, and classroom space. During the antebellum period, many colleges, including Mercer and Wake Forest, considered manual labor an essential component of the curriculum; students were required to work two and one-half hours per day in the fields, while professors were not required but expected to work alongside them. This component was short lived, as the sons of slave owners viewed manual labor with contempt. On May 1, 1837, a fire consumed the schoolhouse and killed one student, Francis Goddard, of Georgetown. Pictured above is the second classroom building for Furman Institution near Winnsboro, erected 1837. In 1886, an earthquake destroyed the third floor, and the building was demolished in 1998. This photo was taken in 1949.

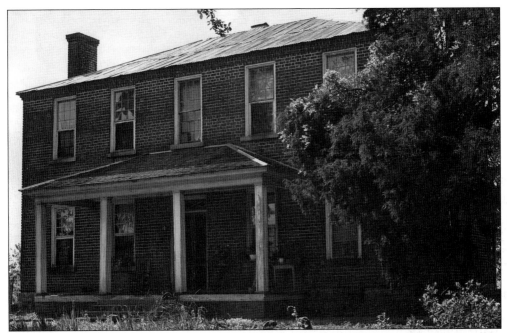

The above photo features the home of the head of Furman Institution in Fairfield County. Furman remained in Winnsboro until the convention voted on June 16, 1850, to move the campus to Greenville, citing the climate, larger population, and developing railroad as the motivations behind such change.

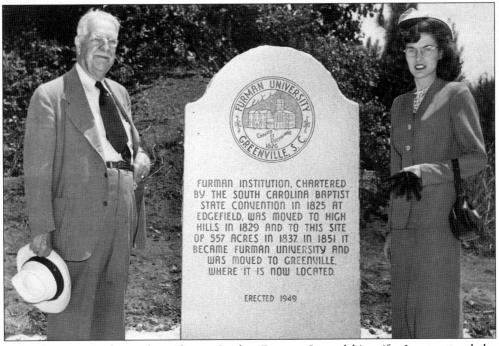

Richard Furman's descendant Alester Garden Furman Jr. and his wife, Janet, attend the unveiling ceremonies of the historical marker at the site of Furman Institution near Winnsboro on May 12, 1949.

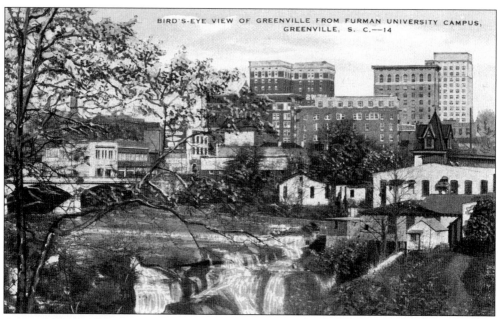

In 1850, Furman's trustees decided to move to the Upstate of South Carolina, a place with an established history of Baptist education. Vardry McBee, the "father of Greenville," was responsible for much of Greenville's early development. Among his many contributions to the developing village include the donation of lands for the establishment of Baptist-affiliated male and female academies in 1821, and the sale of what would become the downtown campus near the Reedy River for less than half its appraised value to Furman trustees in 1850. In 1850, the boys' academy closed, followed by the girls' academy in 1854. Subsequently, that land became the campus of the Greenville Baptist Female College in 1854.

BIRD'S-EYE VIEW OF GREENVILLE FROM FURMAN UNIVERSITY CAMPUS, GREENVILLE, S. C.—14

Over a century after the move, this postcard depicts the view of a developed downtown Greenville that Furman students enjoyed from their campus. In the foreground is the Reedy River Falls and in the center top of the postcard is the famed Poinsett Hotel, where guests traveled hours out of their way to stay, and received change in ironed dollar bills and freshly scrubbed coins.

18

Two

ADMINISTRATORS
AND MAJOR EVENTS

Since 1859, when Furman University offered its presidency to James C. Furman, only ten individuals, including Furman, have held the office. President Furman attended Furman when it was a fledgling academy and theological institution, and his unique relationship to the institution foretold its future; the past five presidents of Furman have also been alumni. President Gordon Blackwell's fireside chats, President John Johns' notorious FU cheers, and President David Shi's midnight study outings with students at the Waffle House illustrate the unique camaraderie between students and university staff, faculty, and administrators.

Since 1992, Furman presidents have lived at White Oaks, an elegant home given by Mrs. Homozel Mickel Daniel upon her death. Furman presidents wear a medallion with the university's seal at convocation, and process with the macebearer. Furman commissioned the mace and medallion in 1964 for the inauguration of President Gordon W. Blackwell. Former Chair of the Art Department Thomas Flowers designed and created both; the mace and medallion were carved from walnut and include silver ornamentation. The four-sided, three and one-half foot long mace includes the seal of Furman University, the seal of the Greenville Woman's College, the Furman family crest, and a piece of wood from the old men's campus inscribed with the date 1961, the year that the men's and women's campuses united on the Poinsett campus.

Furman's presidents have benefited from the support and leadership of a remarkable group of trustees, staff, and faculty members. The contributions of individuals such as Jesse Hartwell, Charles Judson, Mary Camilla Judson, Sidney Ernest Bradshaw, Alester G. Furman Jr., Francis Bonner, and Minor H. Mickel, among others, are extraordinary. The president's cabinet includes six vice-presidents, in charge of various university operations. In addition, Furman's Board of Trustees and Advisory and Parents Councils provide guidance and support. Trustees Emeritus include Lloyd Batson, Alester Garden Furman III, Sarah Belk Gambrell, Thomas S. Hartness, Ralph S. Hendricks, Minor H. Mickel, Mary Peace Sterling, and William R. Timmons.

Richard Furman's son James C. Furman joined the academy as a professor in 1844 and became head of the academy and institution one year later. When Furman Academy and Theological Institution moved to Greenville, he transferred with it, and after Furman was rechartered as The Furman University, he became its first president in 1859. James C. Furman steadfastly supported the university through the Civil War, and afterwards, when it came perilously close to closure due to post war financial struggles. When a friend admonished Furman to abandon the university, he is said to have replied: "No, I have nailed my colors to the mast and if the vessel goes down, I will go down with it."

Although Dr. Furman lived on campus during the week, he lived at Cherrydale, a 1,200-acre estate several miles north of Furman's downtown campus, on most weekends and during the summers. The horse-and-buggy ride between the antebellum estate and Furman took about 90 minutes. In this 1890 photo of Cherrydale's front and side lawn are Eugene Kincaid Furman, next to the buggy on the far left, and the Furmans' former slave Abraham, visible to the right of the buggy and shrub. Although the man, woman, and child sitting on the right under the trees are unidentified, it is likely that the man and woman are Dr. James C. Furman, in the year before his death, and his wife, Mary Glenn Davis.

On March 7–8, 1999, Furman moved Cherrydale, a 4,960-square-foot home, from its location several miles from the Poinsett Highway campus. The Stone family, who had purchased the home from the Furmans in 1939, and AIG Baker donated the home to Furman. Cherrydale now serves as the alumni house and provides office space for the alumni office. Preservationists believe the historic home was built in the late 1840s or early 1850s. (Courtesy of Courtney Tollison.)

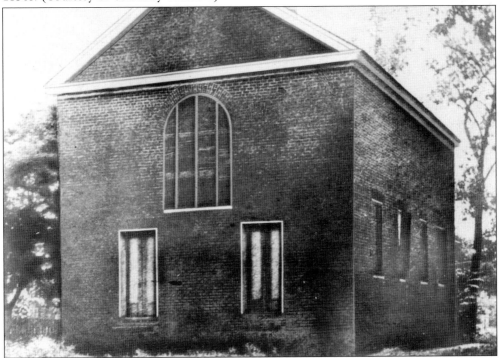

This rare mid-19th-century photo shows the original building of Greenville's First Baptist Church (FBC), which was erected in 1826 on Avenue Street, now East McBee, and faced west. Chairman of the seminary faculty James Petigru Boyce rented the vacant building, which became the first home of the Southern Baptist Theological Seminary, an outgrowth of the Theological Department of Furman University, in 1859.

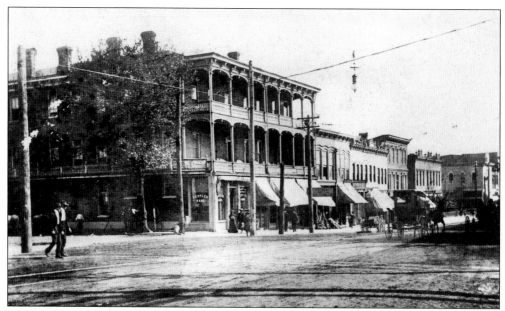

This building, located at the southeast corner of Main and Washington Streets in downtown Greenville, was constructed as a hotel, the Goodlett House, and later used as a Confederate hospital during the Civil War. The seminary purchased it soon after the war and used it until the seminary moved to Louisville in 1877.

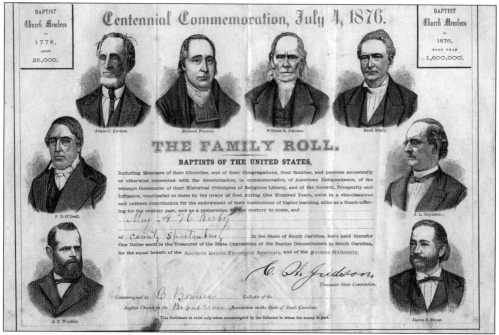

In the centennial year of America's Declaration of Independence, donors to Southern Baptist Seminary and Furman University received this pledge certificate. The certificate features individuals prominent among South Carolina Baptists. From bottom left are E.T. Winkler, J.B. O'Neall, James C. Furman, Richard Furman, William B. Johnson, Basil Manly, J.L. Reynolds, James P. Boyce.

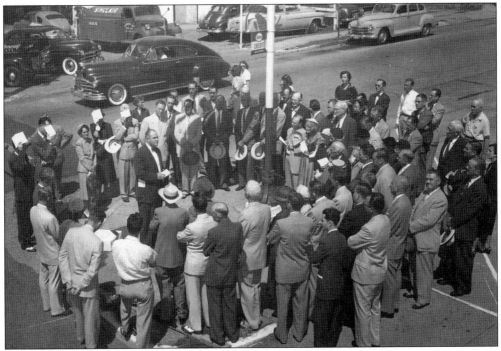

On September 14, 1953, the South Carolina Baptist Historical Society unveiled a historical marker on the site of the original location of the Southern Baptist Seminary in downtown Greenville. Dotson M. Nelson was the speaker.

Alexander Sloan Townes was president of Greenville Female College from 1878 to 1894. The GFC awarded its first Bachelor of Arts degree during his tenure. One of the Lakeside Housing buildings on the Furman campus is named for him.

Charles Hallette Judson spent nearly 60 years at Furman. When the college department of Furman University began offering classes in Greenville in 1852, Judson was one of four professors who taught the 68 students. Judson also served as dean, professor, and professor emeritus of math from 1851 to 1907, university treasurer from 1855 to 1894, trustee from 1857 to 1897, president of the Greenville Female College from 1864 to 1878, and interim president of Furman from 1902 to 1903. From 1851 until his death in 1907, Judson donated $50,000 to help Furman during several decades of financial strain.

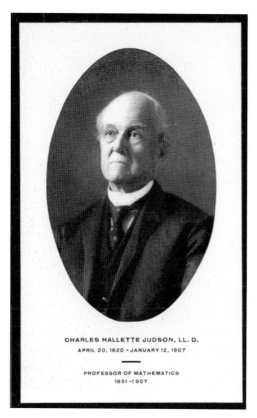

CHARLES HALLETTE JUDSON, LL. D.
APRIL 20, 1820 – JANUARY 12, 1907

PROFESSOR OF MATHEMATICS
1851–1907

Charles H. Judson's sister, Mary Camilla Judson, was the principal of the Greenville Female College from 1878 to 1903. Judson began teaching at the Greenville Female College in 1857 and devoted the remainder of her life to the college. Judson maintained high academic standards while guiding the development of strong music and art programs. After her death in 1920, Greenville Woman's College (the name changed in 1916) students carrying daisy chains on Class Day frequently walked several blocks to adorn Judson's grave in Springwood Cemetery. Commissioned in 1998, hers is the first portrait of a woman to hang in the boardroom of the administration building on Furman's campus.

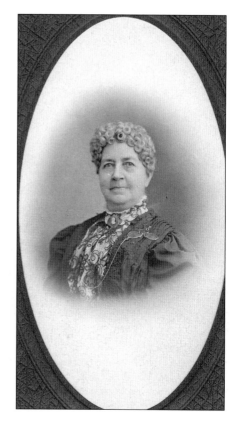

Charles Manly, Furman's second president, assumed duties in 1859. President Manly came to Furman from the pastorate at Greenville's First Baptist Church. During his term of service, Manly added courses in political science, history, astronomy, and modern languages. He supported the development of student activities, coeducation, and allowed the campus to become more residential. Previous administrators felt that dormitory living invited licentious behavior, but Manly supported a residential campus as part of his efforts to add vitality to Furman's non-academic offerings. Subsequently, Furman turned Judson Cottage, Fletcher Hall, and Griffith Cottage into dorms. Students established, with his support, several literary publications; of these, the only remaining publication is the *Echo*. Intercollegiate athletics also began during his presidency. Manly successfully continued President Furman's efforts to gain economic stability. He served until 1897.

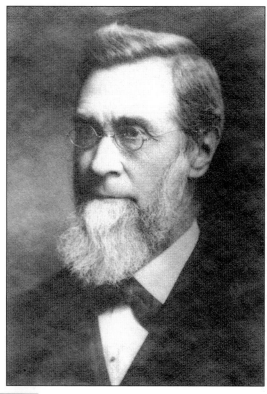

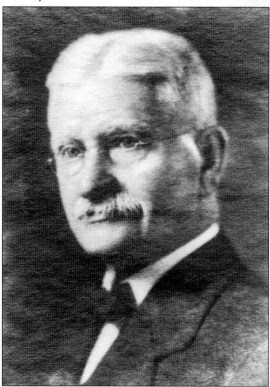

President Andrew Philip Montague was the first lay scholar to serve as president of Furman. Prior to coming to Furman, Montague served as dean of Columbia University. Like his predecessor, Montague encouraged the development of student activities. The publication of the university's yearbook, *Bonhomie*, first appeared as a photographic history of the 1900–1901 academic year. Financial stability strengthened under Montague, and over the course of his term of service, the appearance of Furman's downtown campus changed dramatically. Alumni formed a building fund that initiated construction in the 1890s, which did not end until the Great Depression.

25

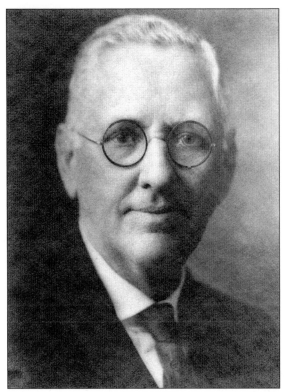

Pres. Edwin McNeill Poteat served from 1903 to 1918 and encouraged the establishment of symbols and traditions that are recognizable to all Furman alumni. Poteat penned the poem that Greenville Female College musical director H.W.B. Barnes set to music; the final product is Furman's *Alma Mater*. The university seal was also developed under Poteat. Among Poteat's administrative priorities was the aggressive recruiting of faculty with advanced degrees in their fields. Under him, Furman hired its first Ph.D., Sidney Ernest Bradshaw. After Poteat resigned to pursue mission work in China, Bradshaw served as interim president for one year until the board hired William Joseph McGlothlin, a professor at Southern Baptist Theological Seminary.

Pres. Andrew Philip Montague was the first lay scholar to serve as president of Furman. Montague assumed the presidency after serving as Dean of Columbia University. Like his predecessor, Montague encouraged the development of student activities. The publication of the first university yearbook offered a photographic history of the 1900-01 academic year. Benjamin Lewis Blackwell, a 1903 graduate and father of future President Blackwell, named the yearbook *Bonhomie*. Under Montague, financial stability strengthened and the appearance of Furman's downtown campus changed dramatically. Alumni formed a building fund that initiated construction in the 1890's, and building projects continued almost uninterrupted until the Great Depression.

After years of compounding debt, GWC supporters realized their only hope of salvaging the institution was to legally merge with Furman. A proponent of coordination, GWC President Herbert W. Provence, shown here, resigned when GWC and Furman began operating under one president and a joint board of trustees in 1933. Some classes became coeducational, with Furman buses transporting students between the men's and women's campuses. Increased coordination between Furman and the Greenville Woman's College of Furman University resulted in a complete merger in 1938.

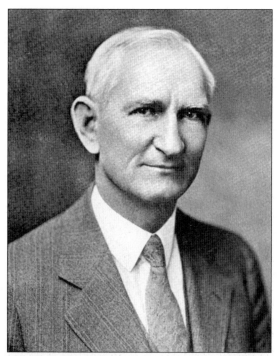

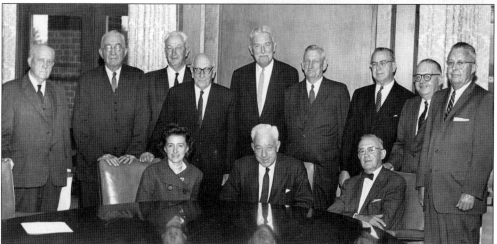

Although the Duke Endowment named Furman a beneficiary of the Duke Endowment during McGlothlin's administration, the inclusion was the result of a conversation in which future Furman president Bennette E. Geer '96 encouraged his friend James Buchanan Duke to remember Furman in his financial plans. When arranging the terms of the endowment, Duke included Furman, or, as he referred to it, "that little college located in Greenville that Ben Geer is such a fool about." Duke asked Geer if five percent of the original $40,000,000 gift would be "agreeable." Furman, along with the other recipients, Davidson College, Duke University, and Johnson C. Smith University, have benefited greatly from Duke funds. Officials from the Duke Endowment met at Furman on November 29, 1960. From left to right, seated: Mrs. Mary D.B.T. Semans, Chairman T. L. Perkins, R. G. Rankin; standing: Dr. W. S. Rankin, W. S. O'B. Robinson, M. I. Pickens, Honorary Chairman N. A. Cocke, P. B. Heartt, B. F. Few, K. C. Towe, Treasurer R.E. DuMont, and T. F. Hill.

Bennette Eugene Geer, an 1896 and 1897 (MA) graduate of Furman, was the first person to serve as the president of both Furman and the GWC. Geer, whose mentors were Charles H. Judson and President Manly, was the first Furman graduate to lead the university. As a young man, Geer was unable to afford a college education. President Charles Manly arranged for Geer to attend Furman, and invited the young Geer to live in his home. After graduation, Geer became a professor of English at Furman, and dean after Judson's death. As president, Geer deepened Furman's relationship with the city of Greenville. He was Furman's first administrator to aggressively pursue grants and other forms of financial support. His progressive attitude was not always popular with Baptists and some alumni, although Furman rose to unprecedented levels of prominence during his administration. Since Geer, every president of Furman has also been an alumnus.

John Laney Plyler '13 is Furman's longest serving president. The Furman that Plyler assumed the reins of in 1939 was vastly different from the Furman he left in 1964. In his first year of office, Furman trustees approved the American Association of University Professors' 1940 *Statement of Principles of Academic Freedom and Tenure*. Plyler considered this one of his proudest accomplishments. An increasing desire to operate on one campus and years of debate regarding problems of overcrowding motivated Furman trustees to purchase land for the new campus in 1950. Under Plyler, Furman become fully coeducational and trustees voted to racially desegregate. President and Mrs. Plyler's vision directed the new campus' development, which provided a solid foundation upon which Furman has grown.

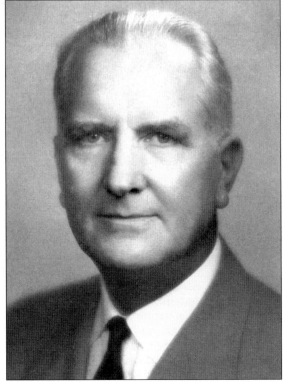

After graduating from Furman, John Plyler served in World War I. He received his J.D. from Harvard Law School in 1921 and later became a judge of the Greenville County court. Plyler was dean of the Furman and became a member of the board of trustees in 1937, two years before he assumed the duties of the presidency. His experiences and familiarity with the military benefited Furman during his years as Furman's World War II president. Plyler attracted military training programs to the campus during the war when male enrollment dropped dramatically, and instituted the Army ROTC program at Furman in 1950.

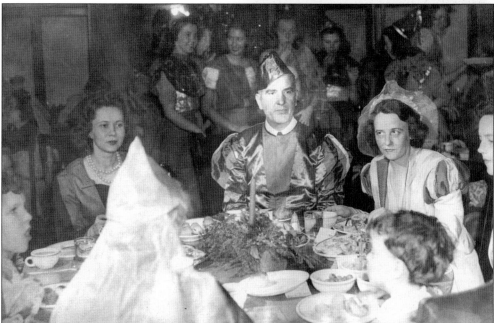

Plyler began presidential duties soon after the complete merger of GWC and Furman. Here, Plyler and Dean of the Woman's College Elizabeth Lake Jones participate in the annual Hanging of the Greens festivities in 1945. Hanging of the Greens was a GWC tradition that began in December 1933 and included a medieval feast and performances by the choir and orchestra. Seated at the table are Plyler (second from left) and Elizabeth Lake Jones (third from left). Mrs. Beatrice Plyler sits at extreme left.

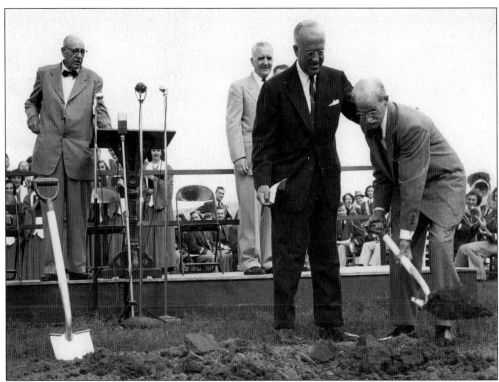

Participating in the groundbreaking ceremonies for the new campus on October 6, 1953, are, from left to right, (stage) Dr. John Dean Crain, President John Laney Plyler; (foreground) Alester Garden Furman Jr., and David Marshall Ramsay. Alester G. Furman, great-grandson of Richard Furman, was the first person to break ground. Below, students, faculty, and other guests observe the groundbreaking, which took place near present-day McAlister Auditorium. Paris Mountain is in the distance.

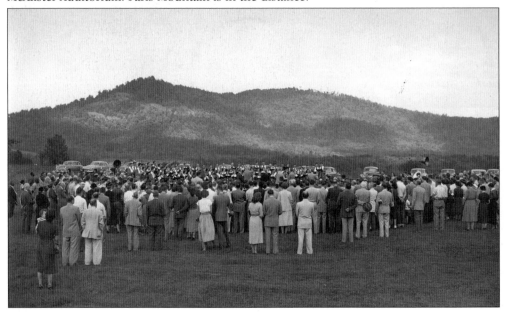

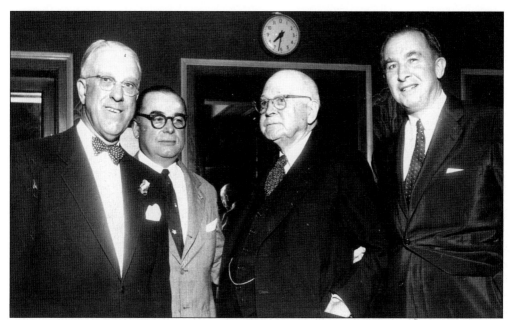

Chair of the Board of Trustees and major proponent of the new campus Alester G. Furman Jr. hosts a banquet honoring Duke Endowment trustees on April 24, 1956. The trustees decided earlier that day to name the new library for James Buchanan Duke. From left to right are Alester G. Furman Jr., Robert C. Dean (the architect of the new campus), George C. Allen (chairman of the Duke Endowment), and Charles E. Daniel (generous Furman supporter and founder of Daniel Construction Company).

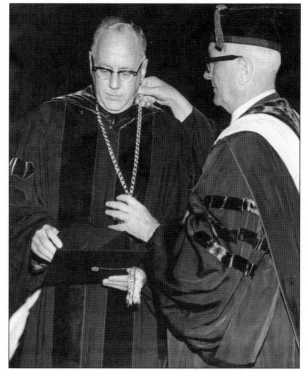

Gordon Williams Blackwell '32 immediately brought vigor to the campus when he established "excellence by national standards" as his goal for Furman months before taking office. An esteemed scholar, Blackwell came to Furman from Florida State University, where also served as president. During his 11 years at Furman, the university desegregated, constructed the Watkins Student Center, and was awarded a Ford Foundation grant and a Phi Beta Kappa chapter. Blackwell continued President Geer's progressive leadership and initiated Furman's ascent as an institution of national stature. Here, President Plyler puts the new university medallion on incoming President Blackwell.

31

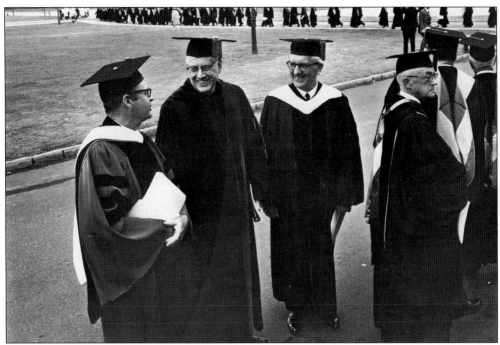

During his student days at Furman, Dr. Blackwell was captain of the tennis team, the editor of the *Echo*, and president of the band and his fraternity. He graduated *summa cum laude*. In this photo, Dr. Blackwell, second from left, shares a laugh with Duke University President Douglas M. Knight, far left, and President Emeritus Plyler, third from left, while the faculty process into his inauguration in McAlister Auditorium.

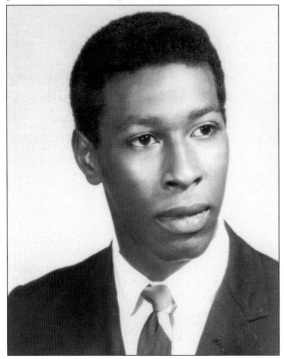

Interim President Dr. Francis W. Bonner and incoming President Blackwell understood that desegregation was an essential ingredient of institutional progress and furthered earlier efforts to desegregate. Bonner and Chair of the Board of Trustees Sapp Funderburk hand- selected a student to desegregate the campus: Joseph Allen Vaughn, photographed here as a senior at Greenville's Sterling High School, was Sterling's student body president, a member of the honor society, and attended a Baptist church. Amidst opposition from the SCBC, Trustees admitted Vaughn and three African American graduate students on February 2, 1965, the same day Gordon Blackwell assumed duties as president. (Courtesy of Jim Stewart)

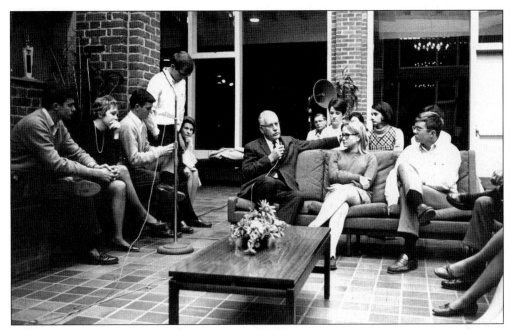

Blackwell's insistence on open communication throughout his presidency, as seen here in 1968 during one of his fireside chats, was important during this time of racial change and student unrest. Throughout his tenure, he encouraged students to express their opinions regarding the quality of academic and social life at Furman.

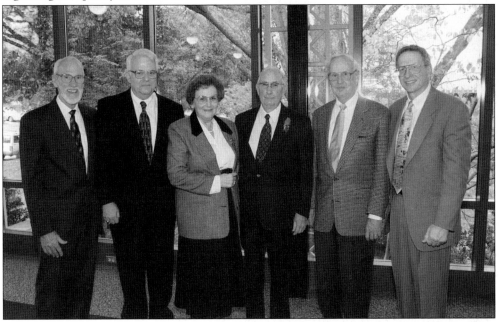

Peggy Park began working at Furman as an assistant to Dean Francis W. Bonner on February 1, 1961. After Bonner retired in 1982, she worked under four successive deans: Dean Emeritus Dr. John Crabtree, Dr. David Shi, Interim Dean Dr. Ray C. Roberts, and Dr. A.V. Huff. After 40 years at Furman, Park retired in 2001. From left to right are Roberts, Huff, Park, Bonner, Crabtree, and Shi.

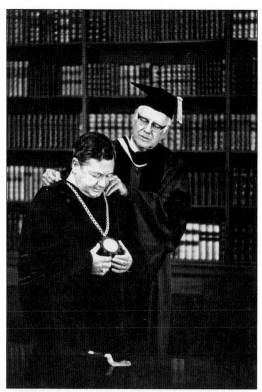

During President John E. Johns's tenure as president, Furman built Paladin Stadium and Riley Hall, established the Furman Advantage Research Program, won the Division I-AA National Football Championship, and broke ties with the South Carolina Baptist Convention. Johns '47 and his wife, Martha, the first alumna to serve as first lady, were the first presidential couple to live in White Oaks. Johns's tenure is the third longest in university history. In the top photograph President Emeritus Blackwell helps Johns prepare for Johns's inauguration in 1976.

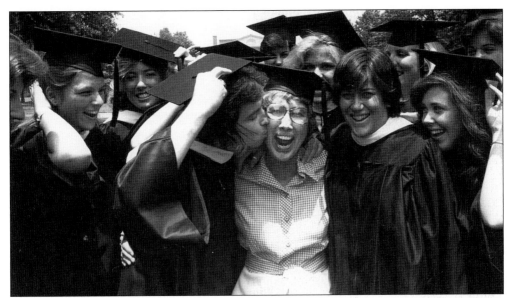

Marguerite Chiles '40, pictured above in 1980 after giving the commencement address upon her retirement, is a charter member of Furman's Hall of Fame. She came to Furman as director of student personnel for women in 1942. Under President Johns, she became Furman's first female vice-president and Furman's first vice-president for student affairs. Chiles retired in 1980, whereupon Furman awarded her an honorary Doctor of Humanities degree.

Professor Emeritus Ernie Harrill, below, began teaching in Furman's political science department in 1949 and served as dean of students from 1962 to 1968. The Chiles-Harrill Award honors a faculty or staff member that has contributed significantly to the lives of Furman students. Established by Frank Keener '64, the first award was given in 1998. Some recipients include Betty Alverson '57, Lib Nanney, Carol Daniels '82, Nancy Cooper, Faye Jordan, Myra Crumley, Sgt. Paul Harris, and Elaine Cloer.

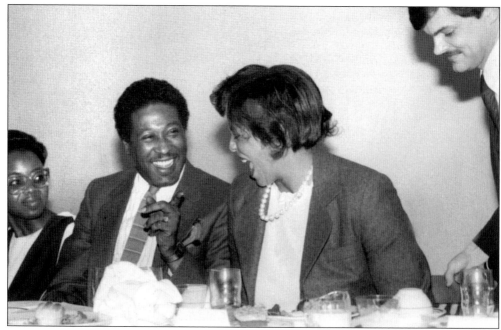

In 1985, Furman hosted a 20th anniversary celebration of Furman desegregation entitled "A Look Back . . . A Step Ahead." At this dinner, Joe Vaughn '68 and Lillian Brock (Flemming) '71, who, with Sara Reese '71, became Furman's first African-American female graduates, shared their Furman experiences. Flemming is the first African-American woman to sit on Furman's board of trustees. Furman annually bestows student awards honoring Vaughn and Flemming. This photo of Vaughn and Brock Flemming also includes, at far left, Michele Simpkins '85, and far right, Associate Chaplain Vic Greene '73.

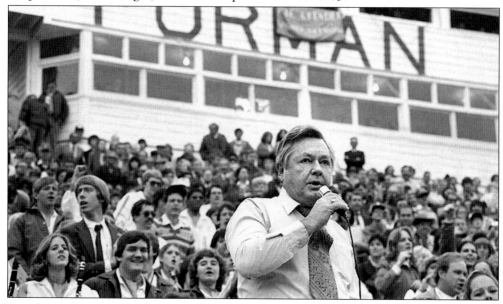

President Johns prepares to give his famous "FU One Time, FU Two Times, FU Three Times, FU All the time!" cheer before the student section at Furman's last game in Sirrine Stadium in the fall of 1985. (Courtesy of Joe Jordan.)

A statue of Alester Garden Furman Jr. (1895–1980), fourth-generation descendant of Richard Furman and longtime trustee who was chairman of the board when Furman decided to move to the new campus, stands in the garden outside the Hartness Welcome Center.

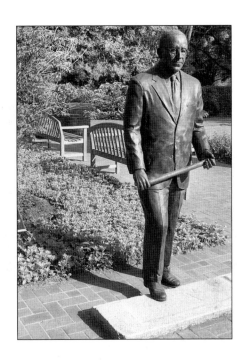

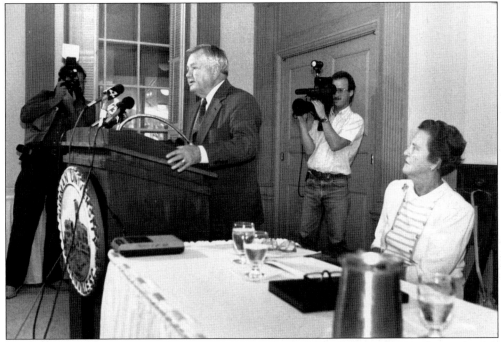

In reaction to the increasing fundamentalism of the SCBC, Furman began discussions with the convention regarding university governance in 1990. After two years of intense debate, President Johns announced in a press conference in the fall of 1992 that Furman's board had voted to become a self-perpetuating body, effectively severing its 166-year relationship with the South Carolina Baptist Convention. Chair of the board of trustees Minor Mickel, the first woman to hold this position, looked on.

37

As a former All Southern Conference football player, member of Quaternion, and *magna cum laude* Furman graduate, the university's tenth president, David Emory Shi '73, has brought a well-rounded appreciation of the Furman experience to the office. Under his leadership, Furman has enhanced its relationship with Greenville and developed a solid national reputation, largely as a result of the university's emphasis on engaged learning. Upon taking office, one of his first major responsibilities was reevaluating the university's Mission and Purpose statement. In addition, "Furman 2001," a campus-wide study designed to identify the university's strategic goals, was completed in 1997. From 1999 to 2001, Furman organized the largest fund-raising campaign in university history. In late 2000, Furman was publicly named a recipient of John D. Hollingsworth's estate, one of the largest individual contributions in the history of higher education in this country, and in 2001 the university celebrated the 175th anniversary of its founding. The construction of North Village apartments fulfilled another of Shi's goals; Furman is now a completely residential campus. In this bottom photo, President Shi performs with Chris Richards '73 at a coffeehouse during his student days at Furman. Offstage, Susan Thomson (Shi) '71, looks on.

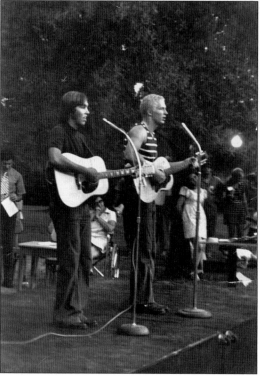

Another of President Shi's priorities has capitalized on one of Furman's existing assets: its campus. New facilities include Eugene E. Stone III Soccer Stadium, the Minor Herndon Mickel Tennis Complex, Johns Hall, Charles Ezra Daniel Memorial Chapel, REK Center for Intercollegiate Golf, an amphitheater, Timmons Arena, North Village, Nan Trammel Herring Music Pavilion, Hartness Welcome Center, Hipp Hall, Pepsi Stadium, the acquisition of Cherrydale, the expansion of the University Center and James B. Duke Library, and renovation of Furman Hall. In this photo, President Shi speaks at the groundbreaking for the James B. Duke Library expansion and renovation on May 16, 2002. Looking on is Trustee Emerita Mary Peace Sterling, who provided substantial funding for a new 61,000-square-foot library wing that is named for her father, Charlie Peace. The Duke Endowment contributed significant support for the renovation.

Dr. Shi joins students during an orientation week tradition in which male freshmen serenade freshman women at midnight.

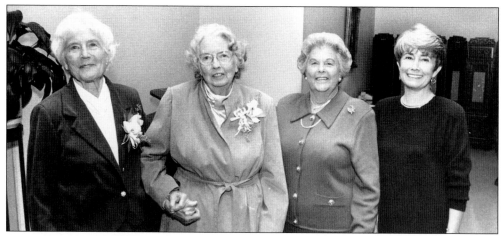

Four of Furman's first ladies gather for a photo in the fall of 1996. From left to right, they are Bea Plyler, Lib Blackwell, Martha Johns '47, and Susan Shi '71. Furman has honored the three former first ladies by naming the two fountains in front of the library for Blackwell and Plyler, and a room overlooking these fountains in Johns Hall (the building named for her husband) for Martha Johns.

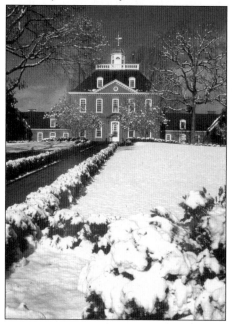

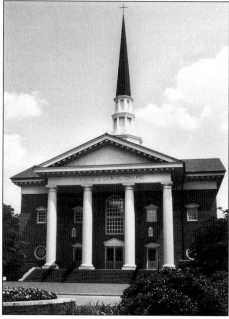

Days after Furman dissociated from the South Carolina Baptist Convention, the university received, at that time, the largest gift in its history. In addition to over $10 million left to the endowment, Mrs. Homozel Mickel Daniel bequeathed to Furman her home, White Oaks, and instructions for the construction of the Charles Ezra Daniel Memorial Chapel to honor her husband. The chapel was completed in 1998. Built in 1957, White Oaks is modeled after the Governor's Palace in Williamsburg, Virginia, and is located less than two miles from Furman's Poinsett Highway campus. In this photo, only the central portion of the 9,750-square-foot home is visible. President Richard Nixon stayed in the home when he visited the Daniels, as have multiple ambassadors and governors. President and Mrs. Johns moved into the home soon after Mrs. Daniel's death in 1992.

Three

BUILDINGS AND GROUNDS
1851–Present

Furman's move to Greenville and subsequent increases in enrollment rejuvenated the institution, which had struggled valiantly to remain in existence since 1826. In 1851, when Furman Academic and Theological Institution moved to its new location in Upstate South Carolina, it operated in two small schoolhouses, and Old Main, with its bell tower, was completed in 1854. After economic stability returned after the Civil War, several more buildings were added over the next several decades as Furman enjoyed a period of relative prosperity. Declining enrollments and financial struggles during the Depression era, however, resulted in several years of poor campus maintenance. This, combined with the merger with Greenville Woman's College, and the influx of students in the post–World War II years contributed to an overcrowded and somewhat dilapidated campus.

Furman University spent 102 years in downtown Greenville before breaking ground on a new 750-acre campus several miles north of the city. The new colonial-style campus developed quickly throughout the 1950s and 1960s. The Plylers' landscaping plans derived from their travels in Europe; the couple's admiration of English gardens and the fountains of Versailles guided their vision.

The university secured the services of the same architectural firm that restored Colonial Williamsburg, Perry Dean Rogers & Partners of Boston. Furman's landscape architect was R.K. Webel of New York–based Innocenti-Webel, who designed the National Mall and areas surrounding the Lincoln Memorial in Washington, D.C. On December 9, 1999, the Society of American Landscape Architects designated Furman's campus a national landmark. A plaque presented during the centennial year of the society's founding sits outside the Hartness Welcome Center.

Furman's lush lawns, manicured gardens, beautiful fountains, 30-acre lake, and 18-hole golf course, all nestled at the base of the Blue Ridge Mountains, impress all who enter her iron gates. Not surprisingly, Furman students frequently refer to their campus as the "Country Club of the South," a phrase whose origin dates to 1951, when Baptist leaders chided Furman's trustees, or "Furman's Country Club Board," as they called them, for developing the majestic new campus.

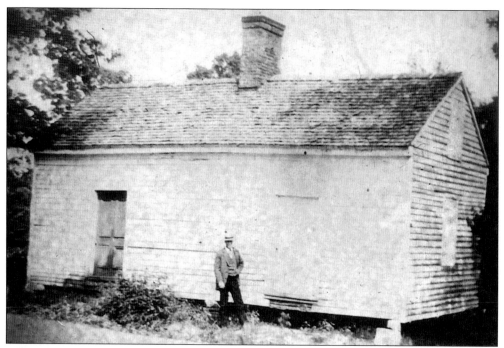

This 1852 schoolhouse was one of two structures used temporarily by the university when it relocated to Greenville. In 1959, Furman moved this building to the new campus, where it sits near the bell tower circle on the lake. Since then, the building has been used as the meeting place for members of Quaternion, the university's most prestigious honorary society for men. (Photo above courtesy of Greenville County Historical Society.)

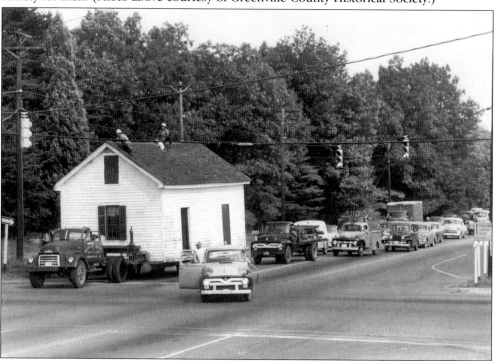

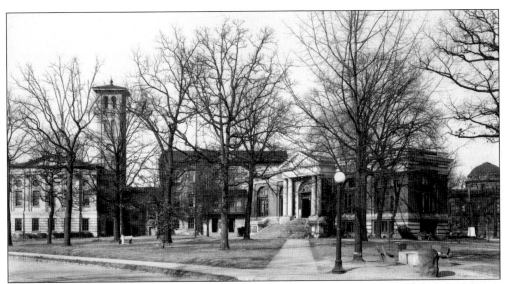

The first permanent building on the downtown campus was "Old Main," completed in 1854. As the only structure on campus used by the college department, the building was referred to as "the university building" and then "Main Building." On June 6, 1921, trustees voted that "Main Building" would become "Richard Furman Hall." A beautiful Florentine bell tower was one feature of the building, and almost immediately, it became the symbol of the new university. To the right of Old Main in the photograph above, taken in 1932, is the Andrew Carnegie Library. In the early 1900s, the Carnegie Foundation challenged Furman to meet its $15,000 pledge for construction of a library. Furman constructed the building in 1906–1907, and named it in honor of Andrew Carnegie. The stone drinking fountain was transported to the new campus and sits in the commons area between Furman and Johns Halls. Below is a similar view c. 1950s. (Photograph below courtesy of Joe Jordan.)

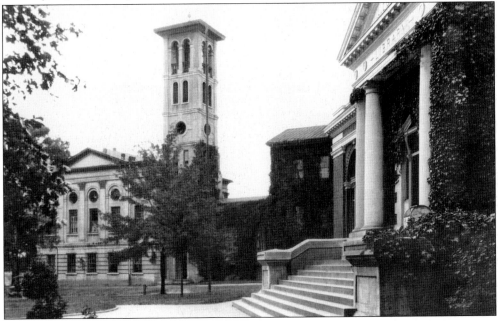

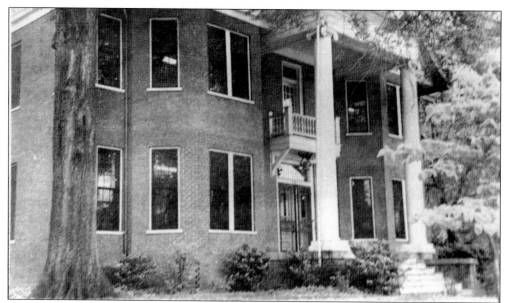

Greenville Female College students helped operate a soldier's rest in this building, the old boys' academy, during the Civil War, and later used it as the campus library for several years. The building was located on the west end of campus off College Street. In 1933, the local United Daughters of the Confederacy placed a stone marker where the building stood that reads, "1862–65 Soldier's Rest. Here is the dwelling where our sick and wounded soldier's found shelter, food, and clothing, and sympathy. The soldier's rest was established and supported by the Ladies Confederate Aid Association." In the donation of land to the old boys and girls' academies, Vardry McBee stipulated that it always be used for educational and cultural purposes. The old woman's college campus is now Heritage Green, home to Greenville Little Theatre, Greenville County Library, and the Greenville Art Museum. (Photo courtesy of Greenville County Historical Society.)

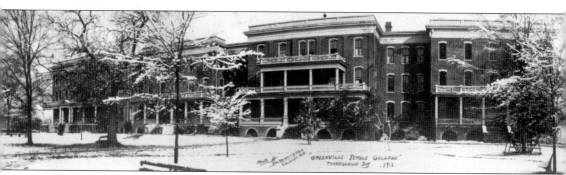

This photo of the Greenville Female College under a blanket of snow was taken on Thanksgiving Day, 1912. The women's campus was only miles away from Furman's campus in downtown Greenville. GWC students lived upstairs in the interconnected row of buildings. The women's dormitory complex on the new campus, now Lakeside Housing, imitates the interconnected nature of the GWC campus. Security and other concerns quashed original plans for the women's dormitories, which consisted of several separate buildings constructed around a lagoon.

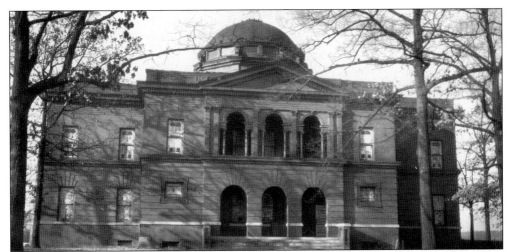

Furman's Judson Alumni Hall, completed in 1900 and named for Charles Hallette Judson, provided an auditorium in which the university held chapel services. The law school opened in 1921, and in 1930 Furman renovated Judson Alumni Hall to give the law school its own space. The law school library was located in the basement of the Carnegie Library. The law school closed in 1932. Soon thereafter, the Greenville Bar Association bought the law school's library for $4,000, and most students transferred into the law schools at Duke University and the University of South Carolina.

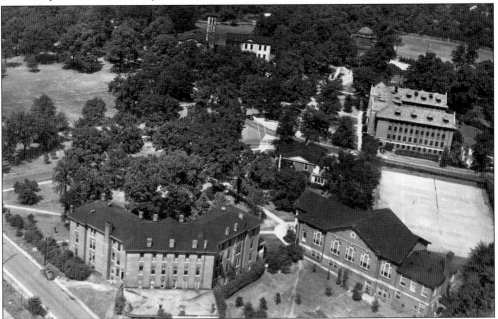

This photo offers an aerial view of Furman's downtown campus. In the lower left is Montague Hall, the first dormitory on the campus, completed in 1901 and named after President Montague's mother. Students lived in private homes in Greenville from 1851 until the mid-1880s, when some students began petitioning for on-campus housing and Furman used several cottages as student residences. The dining hall is in the lower-right portion of the photo, and Geer Hall, a dormitory named for President Geer, is visible in the upper-right corner. Richard Furman Hall is in the top center of the photograph.

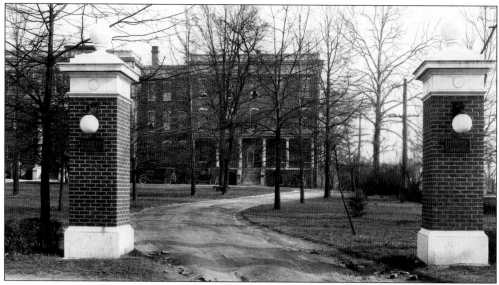

These brick pillars at one of the College Street entrances to GWC's old campus were gifts from GWC Classes of 1920 and 1921. These pillars, in addition to pillars from the GWC Classes of 1922 and 1923, were transported to the Poinsett Highway campus and sit on either side of the roads leading behind Lakeside Housing and leading to the Shack, Cottage, Hut, Old College, and Bell Tower. (Photo courtesy of Greenville County Historical Society.)

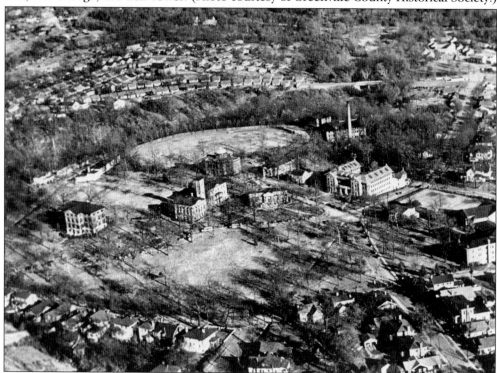

Although available land on Furman's downtown campus was not completely maximized, this aerial shot of the campus and surrounding offers a visual explanation of the concerns regarding lack of expansion space among administrators and trustees.

This drawing maps the men's downtown campus as it was in the years before the move to the Poinsett Highway Campus. The artist is unknown.

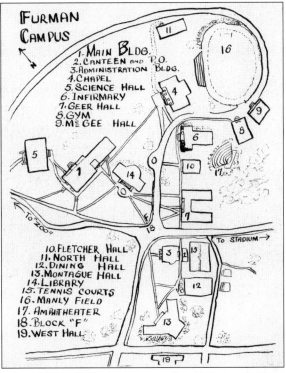

FURMAN CAMPUS
1. MAIN BLDG.
2. CANTEEN and P.O.
3. ADMINISTRATION BLDG.
4. CHAPEL
5. SCIENCE HALL
6. INFIRMARY
7. GEER HALL
8. GYM
9. McGEE HALL

10. FLETCHER HALL
11. NORTH HALL
12. DINING HALL
13. MONTAGUE HALL
14. LIBRARY
15. TENNIS COURTS
16. MANLY FIELD
17. AMPHITHEATER
18. BLOCK "F"
19. WEST HALL

To "ZOO"
To STADIUM →

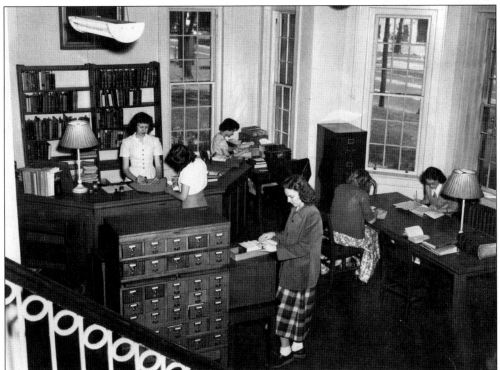

Ann Carpenter sits behind the desk in the GWC's Mary C. Judson Library. The library assistant is Elizabeth Darbin.

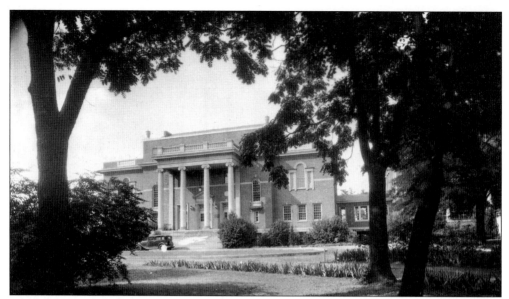

The David M. Ramsay Fine Arts Building on the Greenville Woman's College campus was the primary venue for cultural programs in Greenville for many years. DuPre Rhame coordinated events in the Ramsay Fine Arts Building and in McAlister Auditorium on the new campus. In 1963–1964, bricks from the Fine Arts Building were used to create the area surrounding the fountain circle in front of the old women's dormitory complex, renamed Lakeside Housing.

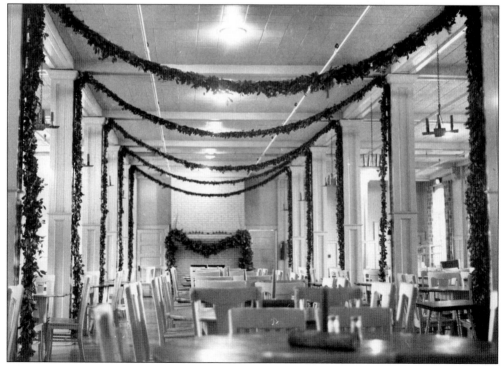

The GWC dining room is decorated for Christmas in December 1960. The 1960–1961 academic year was the last on the GWC campus.

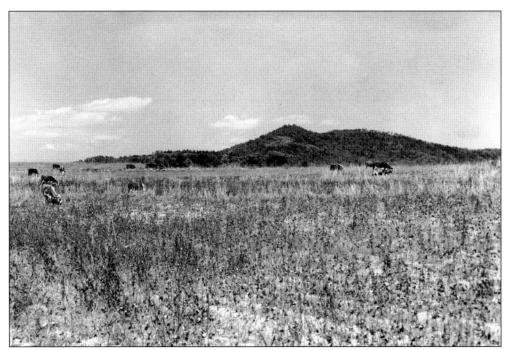

In 1950, Dr. and Mrs. Plyler and trustees selected this site on which to develop the new campus. When they visited the site, it was covered with cotton fields covered and cows roamed the property. After the purchase of 938.26 acres, Furman placed a sign announcing its development. Plyler's campaign slogan for the campus fund-raising drive was "A Greater Furman University for a Greater Tomorrow." (Photo below courtesy of Charlie Register.)

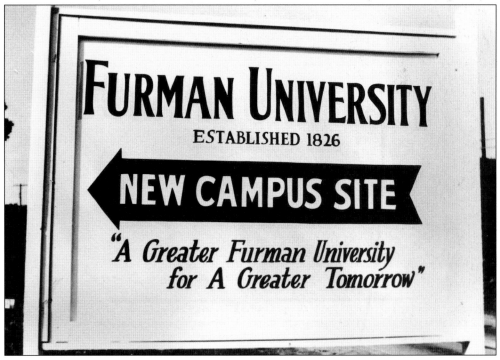

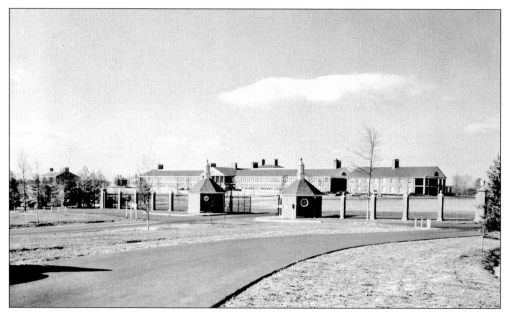

Until the late 1990s, the iron gates of Furman's front and back entrance closed every evening. A public safety officer checked the IDs of those who wished to enter after a certain time. In the absence of trees, the administration building is visible between the two gatehouses.

James C. Furman Hall, erected in 1955, is usually cited as the first construction on the new campus. Furman Hall includes classroom buildings and the Haynsworth Common Room, named for alumnus Clement Haynsworth, a federal appeals court judge and nominee for the Supreme Court during President Richard Nixon's administration. In 2003–2005, Furman Hall underwent extensive renovation. The Furman Hall corridor, a high traffic area during the academic year, is shown here.

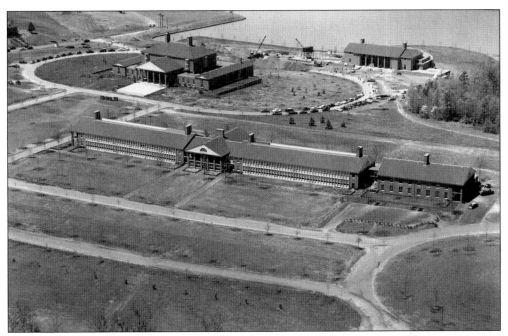

Newly planted oak trees line the mall before the creation of the fountains. This 1958 aerial photograph features the Administration Building and Furman Hall, the James Buchanan Duke Library, and dining hall, under construction. Visible below, in addition to the buildings above, is the men's dormitory complex and one-half of Plyler Hall. The second phase of Plyler Hall was completed in 1966 and had a large lecture room named in 1969 for alumnus and Nobel Laureate Charles H. Townes. The front fountain and Lakeside Housing complex are under construction (Photo above courtesy of Greenville County Historical Society; photo below courtesy of Joe Jordan.)

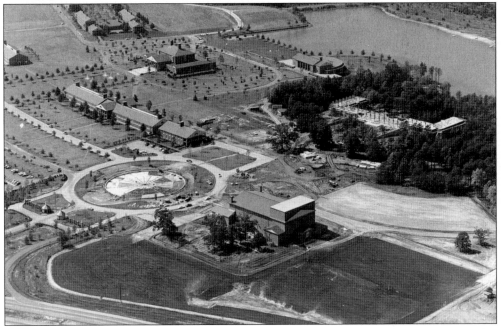

The dining hall, or "DH," is named for Charles E. Daniel, the founder of Daniel International Construction, the largest construction company in the world at one time, now known as Fluor-Daniel. Adjacent to the DH is Hartness Pavilion, a glassed-in room overlooking the rose garden and named for Thomas and Edna Hartness.

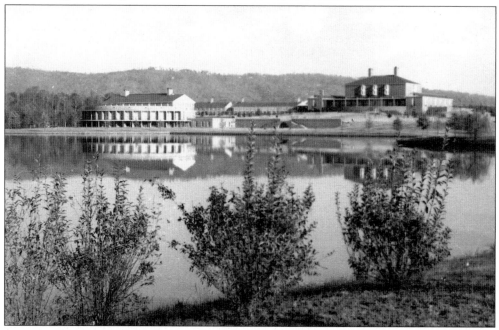

This late-1950s photograph shows the newly constructed Dining Hall and James B. Duke Library. With only small trees, the Administration Building and Furman Hall are visible between the two buildings. Notice the grassy, open area where the rose garden is now located and trees where the Watkins Student Center was constructed in 1965.

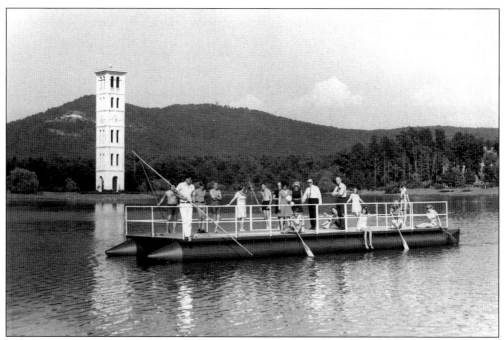

On weekends, Furman's 30-acre lake attracts hordes of visitors, turning Furman's campus into what students jokingly refer to as "Furman State Park." Students through the 1980s sailed, swam, canoed, and fished at "Furman Beach." Here, a group gets out on Furman's old pontoon boat, the *Queen Alverson*, named for Betty Alverson.

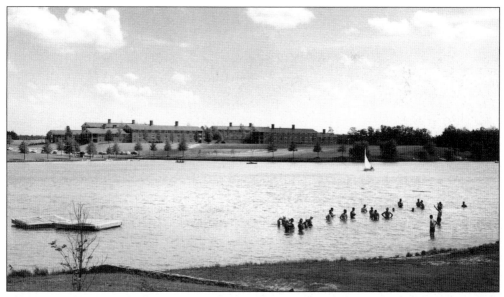

The men's dorms, before the addition of Blackwell Hall, are visible. On April 15, 1958, trustees voted to name the first men's dormitory building, Manly Hall, for Furman's second president, Charles Manly, and the remaining three for Presidents Edwin M. Poteat, William J. McGlothlin, and Bennette E. Geer. The complex has become known as South Housing in recent years.

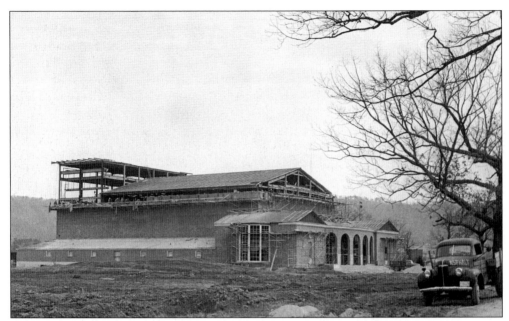

In the fall of 1960, Furman completed construction on McAlister Auditorium, a nearly 2,000-seat auditorium built in part with funding from an estate gift from alumnus William H. McAlister and his daughter Amelie McAlister Upshur. The foyer features sculpted busts of former Furman presidents. The above photo was taken during the construction of McAlister Auditorium in 1959–1960. The photo below features the completed McAlister with the front gate fountain. McAlister Auditorium's lobby was a very popular venue for receptions and other events in the 1960s.

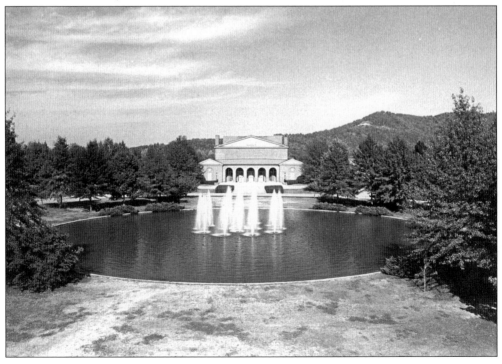

Lakeside Housing, formerly the women's dorms, is a complex with seven connected buildings. The buildings are named for Mary Camilla Judson, first "Lady Principal" of the Greenville Female College; Alexander Sloan Townes and David Marshall Ramsay, former presidents of Greenville Female College and GWC, respectively; Harry John Haynsworth, former treasurer and trustee; Vardry McBee, who donated land that became the Greenville Woman's College; Mary Latimer Gambrell, Greenville Woman's College alumna and former president of Hunter College in New York; and Marguerite Moore Chiles, who, as vice-president for student services, was Furman's first female vice-president. The first two buildings are Judson Hall and Haynsworth Hall, built in 1961. The blue-and-gold Greenville Woman's College seal is barely visible above the columns of Judson Hall, the central building in the Lakeside Housing complex. The women greatly opposed the addition of the seal in the spring of 1962, as these women identified as Furman students.

It snowed every Wednesday in March 1960, ensuring that the ground was covered the entire month. This photo shows the campus as it looked before the construction of Johns Hall and Riley Hall.

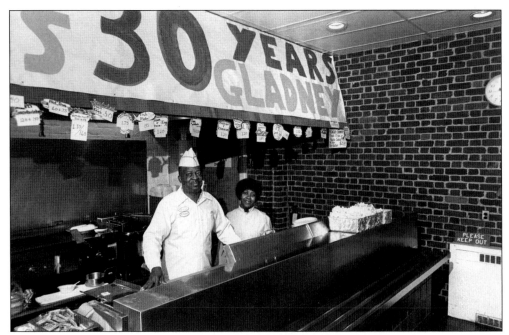

Junius Gladney began working full time in the food canteen and bookstore on Furman's downtown campus in 1952. He became the manager of the Paladen when the student center opened in 1965. Popular among students, faculty, and administrators, Gladney worked at Furman until September 1987, when he suffered a stroke. This 1982 photo was taken on Gladney's 30-year anniversary at Furman. Frances Holmes, another longtime employee, stood behind Gladney.

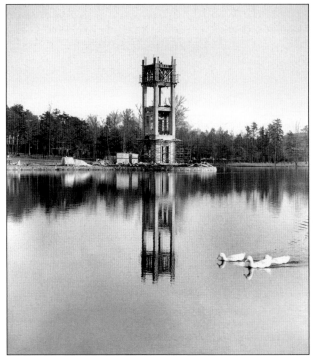

This 1964 photo shows the construction of the Bell Tower on the peninsula, which had to be widened from its original width of six feet before construction began. Oak beams that run 52 feet into the ground stabilize the tower. (Courtesy Joe Jordan Photography)

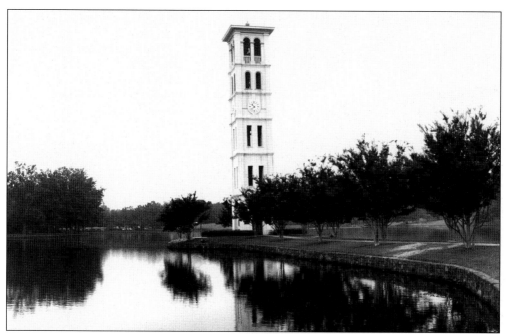

This photograph offers a view of the peninsula upon which the Bell Tower stands.

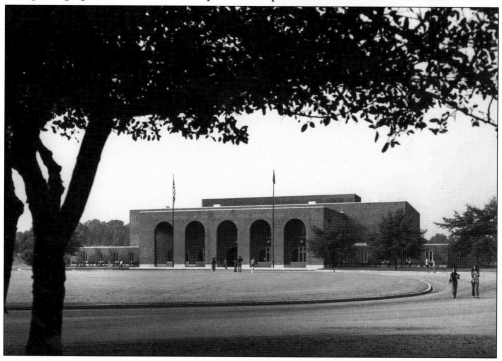

The Herman W. Lay Physical Activities Center provides a fitness center, pool, dance studio, gymnasium, and climbing wall and also houses the Health and Exercise Science Department and Bryan Center for Military Science. The PAC, as it is known among students, was erected in 1973 and is named for the founder of Frito-Lay Corporation and former CEO of Pepsico, a former Furman student.

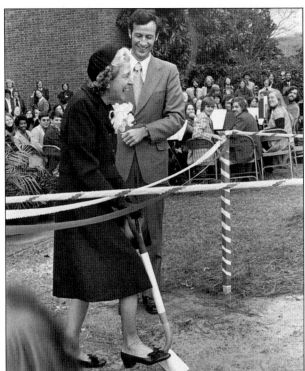

The Homozel Mickel Daniel Music Building was erected in 1975. Here, Dr. Milburn Price stands behind Mrs. Daniel during the groundbreaking ceremony. Dr. Gordon W. Blackwell and Mr. Buck Mickel were also in attendance.

Watkins Student Center, named after Henry Hitt and Maude Wakefield Watkins, opened in late summer of 1965 with a post office, campus bookstore, offices for student organizations, and the Pala-den, a soda shop that provided a popular dining alternative to the dining hall. Additionally, Burgiss Lounge provided a relaxing space for students, and the Thomas Room, named after Evelyn Thomas (dean of the woman's college from 1931 to 1943), served as a small meeting room. The Watkins Center provided much-needed space for students and became the center of campus activities. The first director of the Watkins Student Center was Betty Alverson '57.

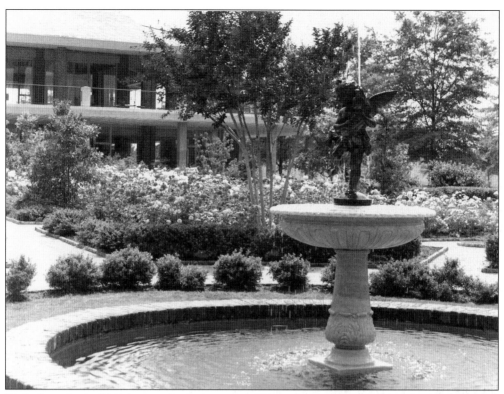

Excluding the Bell Tower, perhaps the most recognized landmark on campus is the Janie Earle Furman Rose Garden. The garden has 800 rose bushes in 21 varieties, and is supported by over 2,000 plants. Nearly everyday students traverse the brick pathways in the rose garden, located between the Daniel Dining Hall and the University Center.

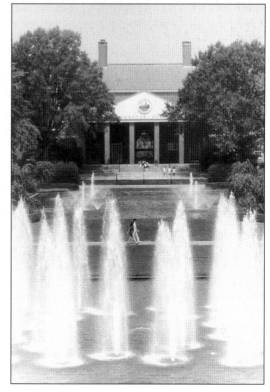

In the fall of 1996, trustees honored former First Ladies Beatrice Dennis Plyler and Elizabeth Lyles Blackwell by naming the fountain closest to the chapel for Plyler and the fountain closest to the Duke Library for Blackwell. This photo features the Plyler and Blackwell fountains in front of the James Buchanan Duke Library.

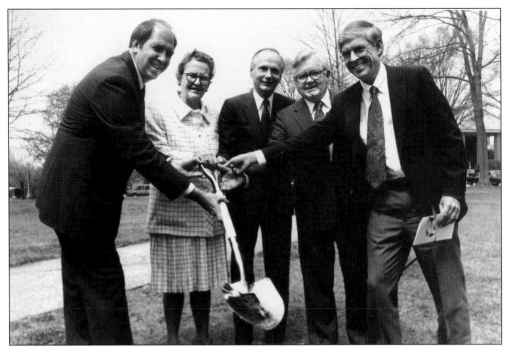

Richard W. Riley Hall is named in honor of Furman's two-term governor of South Carolina and U.S. Secretary of Education during President Clinton's administration. Completed in 1994, the building houses the Departments of Computer Science and Mathematics. Shown above are, from left to right, Dr. Ken Abernethy, Minor Mickel, Richard Riley, President Johns, and Dr. Bob Fray. Below, Riley Hall is seen with the Blackwell fountain in the foreground. (Photos courtesy of Charlie Register.)

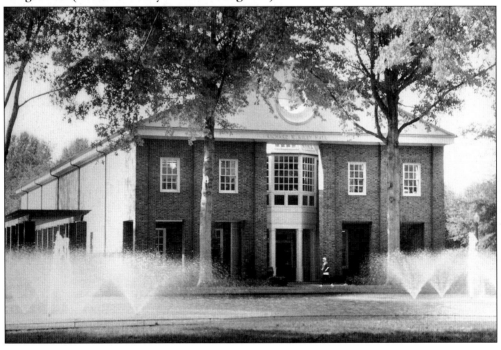

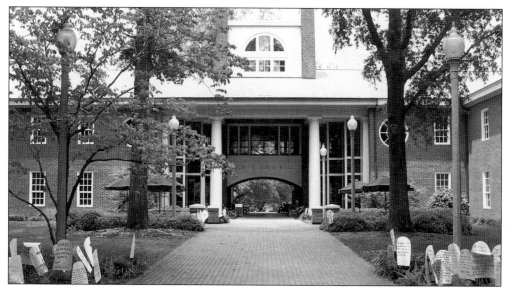

Dedicated in 1998, John E. Johns Hall houses psychology, sociology, and political science, the Richard Riley Center for Government, Politics, and Public Leadership, Center for International Education, and the Christian A. Johnson Center for Engaged Learning. During the psychology department's transition from the basement of Plyler Hall to the new Johns Hall, longtime psychology professor Charles Brewer led a funeral procession, complete with a student trumpeter, around campus and through a trustees meeting. When asked if he would miss the basement, Brewer is said to have replied, "I'll miss it like I might miss cholera." The cardboard headstones visible in this 2004 photo show one student organization's protest against domestic and other forms of violence.

Herman N. Hipp Hall, completed in 2002, is the first Leadership in Energy and Design (LEED) building in South Carolina and one of very few in the South. LEED-certified buildings conform to very high standards of environmental friendliness and efficiency. The building is named for Hipp, a 1935 graduate, Greenville civic leader, owner of Liberty Life Insurance Company, and lifelong Furman supporter. (Courtesy of Courtney Tollison.)

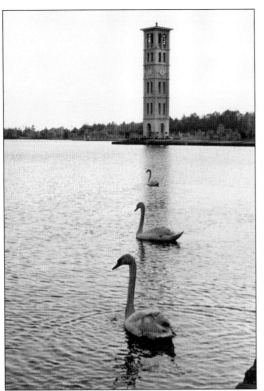

The legendary swans of Furman's lake have never confined themselves to the lake. Seemingly undeterred by campus foot traffic, they frequently appear in the library fountains and in the rose garden and are the source of much amusement.

A student in the early 1990s selects a relaxing place to study.

Four

ACADEMICS
and CULTURAL LIFE

At Furman, "engaged learning" is a priority inside and outside the classroom, and perhaps the most distinctive characteristic of a Furman education. Inherent in Furman's highly touted academic program is the close relationships between faculty and students; dinners at the homes of faculty members are not uncommon, and scores of graduates count former professors among their closest friends. Other unique offerings include the Furman Advantage Program, a faculty-student research program, the Christian A. Johnson Center for Engaged Learning, which promotes a "problem-solving, project-oriented, experience-based approach to the liberal arts," and the Center of Collaborative Learning and Communication. More than 70 percent of students pursue graduate study at some point in their lives.

Furman also offers a thriving cultural environment designed to supplement the core academic program. The Cultural Life Program (CLP), a strict requirement for graduation, ensures that students attend at least nine events each year that have been granted CLP status on the basis of their educational and/or cultural value. In addition, nearly half of Furman students choose to participate in a foreign study program.

In 1924, administrators began efforts to establish a Phi Beta Kappa chapter at Furman. For myriad reasons, many of which concerned issues of academic freedom amidst Baptist restrictions, Phi Beta Kappa repeatedly denied Furman until 1973. Earlier, under President Plyler, Furman became one of a dozen colleges or universities in the South and the first institution in South Carolina to require the SAT for all applicants. Furman boasts six Rhodes scholars, 17 Truman Scholars, and dozens of recipients of Goldwater, Fulbright, and National Science Foundation awards. Notable alumni include the father of behavioral psychology and 1899 graduate John B. Watson, Nobel Laureate Charles H. Townes '35, the U.S. Secretary of Education Richard Riley '54, and Boston Pops conductor Keith Lockhart '81.

In 1858, Mary Creighton Mauldin (Mrs. John Alexander Chambliss) was one of three women who comprised the first graduating class of Greenville Female College.

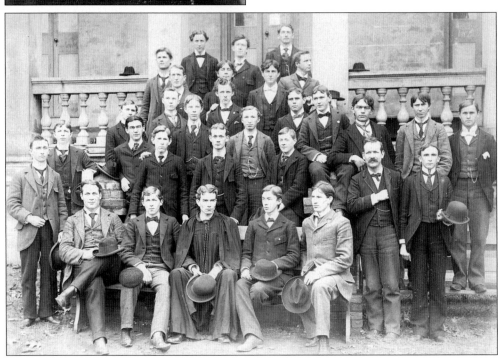

The Adelphian Society is photographed in 1896. Until President Manly's efforts to broaden Furman's social, religious, and athletic offerings, the Adelphian and Philosophian Societies were students' primary extracurricular activities. They also functioned as student government. These literary and oratorical societies, founded in the mid-1800s, met weekly for debate and founded the *Echo*, Furman's oldest remaining publication, in the 1890s.

John Broadus Watson, a Traveler's Rest native and 1899 Furman graduate, is known as the "father of behaviorism." Watson enrolled at Furman at the age of 16; after perhaps intentionally failing a psychology class with controversial professor Gordon B. Moore, Watson stayed an additional year at Furman. At the end of his fifth year, Furman awarded him the master's degree as opposed to the bachelor's degree, and Watson ranked 14th out of 20 in his graduating class. Watson ultimately earned a Ph.D. in psychology at the University of Chicago and took a prominent position at Johns Hopkins University. At the age of 37, he served as president of the American Psychological Association. At Johns Hopkins, Watson developed a behavioral school of psychological thought that contrasted sharply with Sigmund Freud's; excepting Freud, he is considered to have had the greatest impact on the development of psychological thought in the first half of the 20th century. An eccentric man considered somewhat of a playboy by his peers, Watson was forced by the administration at Johns Hopkins to resign after a scandalous divorce and remarriage; Watson successfully spent the rest of his career studying consumer behavior as an advertising executive in New York City. He died in 1958. Lauded psychology professor Charles L. Brewer is a noted authority on J.B. Watson.

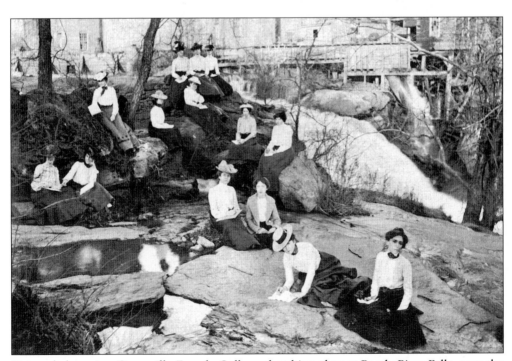

Pictured above is a Greenville Female College sketching class at Reedy River Falls, near the Furman campus, in downtown Greenville.

Professor of Modern Foreign Language Sidney Ernest Bradshaw, who received his doctorate from the University of Virginia in 1900, became the first Ph.D. on the faculty when he began teaching at Furman in 1903. His hiring was part of President Poteat's efforts to strengthen the quality of the faculty. Bradshaw is photographed on Furman's downtown campus in May 1935. The Andrew Carnegie Library is visible behind him.

Furman University

Greenville Woman's College

To all to whom these presents may come

Be it Known that

Nell Edwards

having successfully completed the prescribed course of study and having complied with all other requirements established by the University, has upon the recommendation of the Faculty, been declared by the Board of Trustees a

Bachelor of Arts
Summa Cum Laude

and is entitled to all rights and privileges appertaining to that degree. In testimony whereof, we have hereunto subscribed our names at the Halls of the University, Greenville, South Carolina, this the twenty-sixth day of May A.D. 1936

J. J. Lawton
President Board of Trustees

Alester G. Furman
Secretary Board of Trustees

B. E. Geer
President of the University

R. N. Daniel
Dean

After coordination in 1933 but before the college became the Greenville Woman's College of Furman University in 1938, female college students received diplomas that had the names of both institutions on the diploma, but were signed by Bennette Geer, the joint president; Robert Norman Daniel, Furman's dean; J.J. Lawton, president of the board of trustees; and Alester G. Furman, secretary of the board of trustees. Nell Edwards, summa cum laude, received her degree on May 26, 1936.

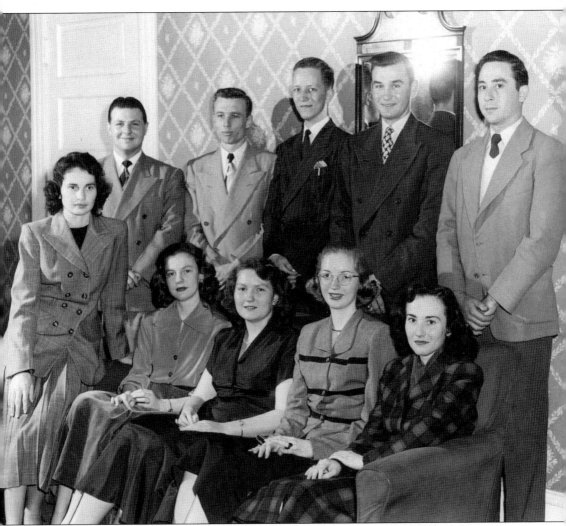

Zetosophia was a scholastic fraternity for women founded on May 24, 1922, at Greenville Woman's College. According to the 1950 *Bonhomie*, women were elected on the basis of scholarship and independent thought. At Furman, the faculty approved Sidney Earnest Bradshaw's recommendation that Furman establish a local scholastic honor society and call it "Hand and Torch," on April 25, 1927. In anticipation of a Phi Beta Kappa chapter someday, the secretary of the United Chapters of Phi Beta Kappa had suggested the formation of such a society to President McGlothlin and Bradshaw, a member of Phi Beta Kappa from the University of Virginia. Members of the 1928 graduating class comprised the first inductees. A 1929 committee limited membership to those ranked in the top-tenth of his/her class. In 1953, Zetosophia merged with Hand and Torch. Furman retired Hand and Torch in 1974, after Phi Beta Kappa granted Furman a chapter. Here, members of Zetosophia and Hand and Torch for the 1949–1950 year are, from left to right, as follows: (standing) Thomas Oliver Kay, Benjamin Walker Thomason Jr., Arthur Walker Lockwood, Philip Gavin Pou Jr., and Chester Henry Holmes; (seated) Thelma Thurman Venters, Alethia Ann Norris, Julia Neal Fields, Frieda Elizabeth Gillespie, and Betty Carolyn Jones.

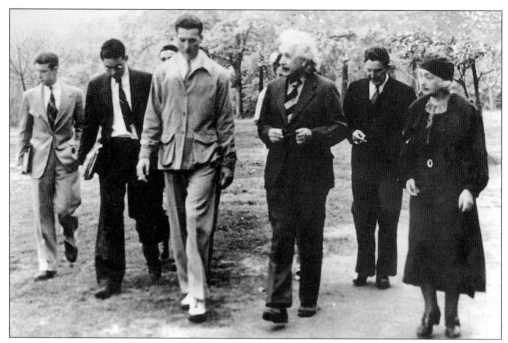

Albert Einstein and his wife strolled around Furman's downtown campus with students as part of his visit during the 1941–1942 academic year. Einstein addressed the university in the chapel. On another occasion, Einstein spoke in Prof. John Sampey's chemistry class. Behind Einstein is Furman English professor C.L. Pittman.

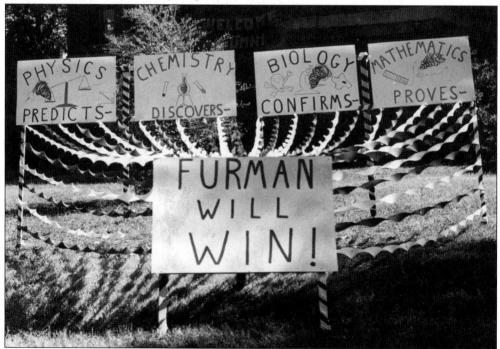

The math and sciences appear to be in agreement regarding the outcome of the homecoming game!

Another of Poteat's hires, Dr. Orlin Ottman Fletcher, seen here, was one member of the very closely-knit faculty, including Bradshaw, Toy Cox, Robert Norman Daniel, Harvey Toliver Cook, and Bennette Geer, from the early decades of the 1900s. Furman students revered these men for their dedication to Furman and for the quality of their character. In 1921, the faculty reissued a moral code that guided students' behavior: no drinking, swearing, dancing, or participation in social fraternities. Class and chapel attendance were mandatory. Here, student Roy Jennings "Hardrock" Smith talks with Dr. Fletcher next to the doughboy in 1936.

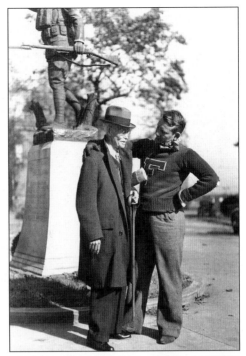

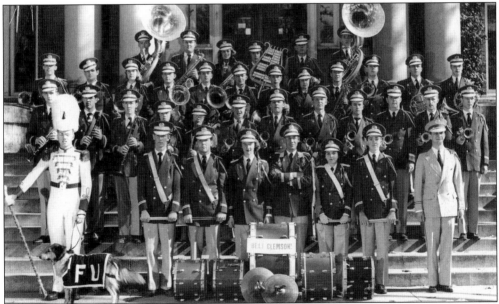

One of the benefits of coeducation for Furman was access to GWC's strong music department. Furman's department reputation is that of a conservatory-quality program, with multiple opportunities for performance. The Furman Symphony Orchestra is one of few all-undergraduate symphonies in the country. Furman's Marching Band, the Paladin Regiment, was founded in the 1910s and has recently performed at halftime of Atlanta Falcons and Carolina Panthers games. In this photo from the 1940s, the Furman band has their photo taken with "Joe College," an abandoned mutt adopted by Furman students who roamed the campus freely and served as a mascot.

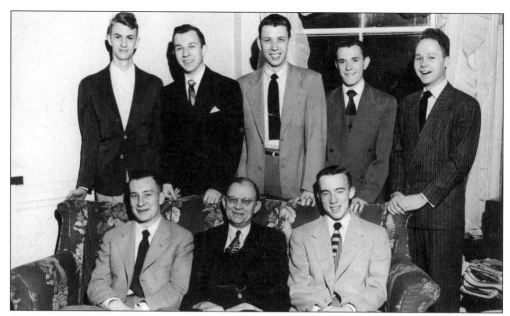

The Cloister is the oldest departmental club. In 1920, the English Department established the first departmental club under Professor and Dean Emeritus Robert Norman Daniel; the club's name was suggested by William Blackburn '21, a future Rhodes scholar. The club was designed to honor superior English students and took charge of the *Echo* from the Adelphian and Philosophean Societies. Students met at Daniel's home on the second Thursday of each month for discussion. Within the next five years, math, history, science, education, and French clubs appeared on campus. In this 1950 photograph, members of the Cloister sit with Dr. Daniel at his home.

Students gathered at the on-campus home of President and Mrs. Plyler to listen to away Furman football games broadcast on the radio. The photo is *c.* 1950.

The Furman Singers are the oldest of the existing choral groups. Low male enrollment during World War II forced the male Glee Club, in existence since 1929, to include women. After war's end, the group disbanded. Dupre Rhame, director of the Glee Club and later, head of the Division of Fine Arts, wanted to maintain a post-war coed singing group; the group of 100 men and women that attended the first meeting voted to call themselves the Furman Singers. In 1949, the singers began closing their concerts while on tour with the "Battle Hymn of the Republic," a tradition that has continued. In this 1955 photo, Furman Singers and the First Baptist Church Choir perform Handel's *Messiah* in First Baptist Church, Greenville. Annual performances of *Messiah* were a Greenville Woman's College tradition started in 1906 by GWC music director H.W.B. Barnes. Upon and long after coordination with Furman University, the tradition has continued.

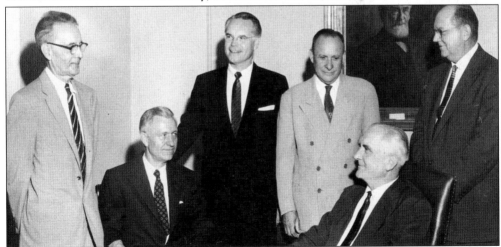

Faculty members representing nearly 200 years of combined service to Furman are pictured in this 1957 photograph. Standing left to right are Dr. Delbert Gilpatrick (better known as Dr. Gilly), DuPre Rhame, Dr. L.H. Bowen, and C.D. Riddle. Seated left to right are Dr. R.C. Blackwell and President John L. Plyler.

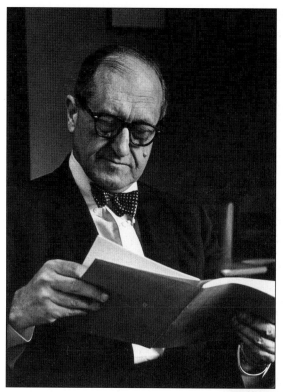

Furman's first Rhodes scholar, pictured below, is Robert Earl Stillwell '67. Although William Blackburn, a 1921 graduate pictured at left, did not pass the regional committee, he was awarded the scholarship in 1924 while attending Yale University. Robert Houston, who attended Furman from 1929 to 1931 and then transferred to Yale, also received the scholarship. Stillwell was student body president, quarterback, president of the Wesley Foundation, and recipient of the ROTC Superior Cadet Award, and is a Methodist minister. Other Rhodes scholars include George Ligler '71, Matthew R. Martin '85, and Robert Johnson '95.

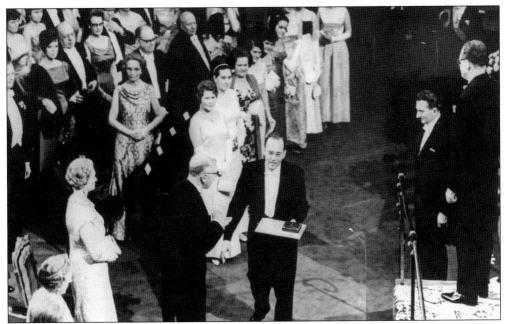

Charles Hard Townes, a 1935 Furman graduate and Greenville native, won the 1964 Nobel Prize in Physics for research that contributed to the development of the laser and maser. Dr. Townes has been recognized as one of the most influential people of the last 1,000 years. He has also been awarded NASA's Distinguished Public Service Medal and the nation's highest award for the sciences, the National Medal of Science. He is Professor Emeritus of Physics at the University of California-Berkeley. The university honored Townes, a trustee, on the 40th anniversary of his Nobel ceremony with a Wall of Honor in the Hartness Welcome Center. This photo shows Dr. Townes at the Nobel ceremony in Stockholm.

Dr. John Crabtree came to Furman as an English professor specializing in Shakespeare in 1957. In 1976, he won the Alester G. Furman and Janie Earle Furman Award for Meritorious Teaching. He retired in 1993, having also served as dean of students, academic dean, and vice-president for academic affairs and dean. In 2003, family and friends established a scholarship in his name.

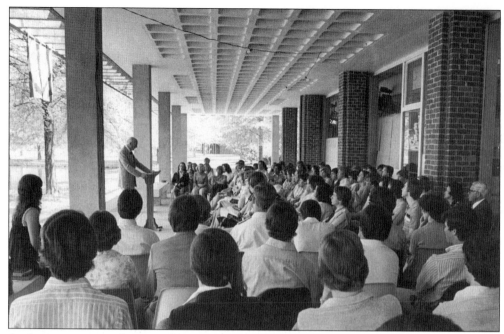

As the new pastor of Greenville's First Baptist Church during an era of tumultuous race relations, L.D. Johnson created quite a stir by openly supporting desegregation. Furman Dean Francis W. Bonner sensed Johnson's discomfort and offered him the position of university chaplain, believing he may be more comfortable in an environment that supported his position. Johnson served as chaplain during a time of student unrest; yet most students respected his fairness and willingness to listen to their concerns. Under his leadership, the Furman Pastors School became the largest theological continuing education program in the country. Johnson's assistant chaplain, Jim Pitts '60, succeeded him in 1981. The university honors Johnson with an annual lecture series, always given by select faculty members and titled "What Really Matters?" As shown in this 1970s photo, Chaplain Johnson conducted Sunday worship services overlooking the lake behind Watkins Student Center.

Here, members of the psychology club strike a Freudian pose for a yearbook photo in 1969.

Professor of English and William Faulkner authority Willard Pate, shown here in 1971 as an associate professor, was instrumental in developing some of Furman's earliest study abroad programs in the late 1960s. In 1970, she became the university's first coordinator of study abroad programs. For years, she directed the Furman fall term program in England, in which students study Shakespeare at Stratford-Upon-Avon and history, politics, or economics in London.

Furman students consider study abroad experiences a highlight of their undergraduate years. The initiation of foreign study programs at Furman resulted from the invigorating vision of Dean Francis Bonner, who began offering faculty foreign study grants in 1963–1964, and who envisioned a similar program for students under guidance from Furman faculty. The first term-length foreign study took place in England in the fall of 1969. In succeeding years, faculty developed programs in Spain (1970), Vienna (1971), Paris (1971), the Middle East (1972), and Japan (1973). Furman faculty members now direct nearly 20 study abroad programs. Furman also has exchange programs with universities in China, Japan, the Netherlands, and South Africa.

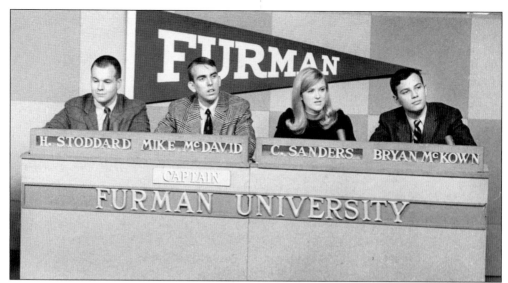

Professors Willard Pate and Don Aiesi (then instructor of political science) were instrumental in training Furman's General Electric College Bowl Team. In 1968, during the height of President Blackwell's drive for "excellence by national standards," the GE Bowl approved Furman's bid for competition. On February 4, 1968, Furman beat the University of Pittsburg on national television in the highest-scoring match in the bowl's history. Two weeks later, Furman beat Georgetown University. In its third match, however, Furman narrowly lost to the eventual winner, the University of Southern California. Ironically, the deciding question regarded the difference between two of Furman alumnus Charles Townes's inventions, the maser and laser.

After several decades of applications from Furman, Phi Beta Kappa, the nation's most prestigious academic honor society, awarded and installed the Gamma Chapter of South Carolina on December 5, 1973, in a ceremony in McAlister Auditorium conducted by historian Dr. John Hope Franklin, president of the United Chapters of Phi Beta Kappa. President Blackwell is seated in front row, center; and Dean Bonner is seated to the far left.

The Furman University mace and medallion were created for the inauguration of incoming President Blackwell in 1964. The most senior faculty member among those who hold the rank of full professor serves as macebearer at university convocations. Here, former Librarian and Chairman of the Faculty Robert C. Tucker shields the mace from the rain in 1975.

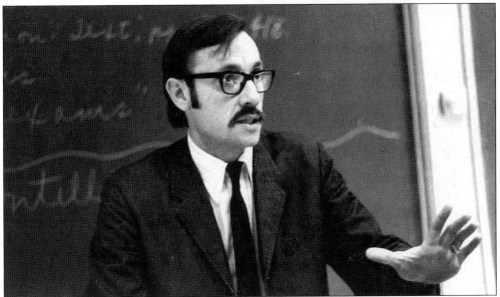

Legendary among Furman students for his rapier wit and support of student endeavors, Charles Brewer has captivated psychology classes at Furman since 1967. Brewer's commitment to teaching (office hours: "7 a.m. to 7 p.m., 7 days a week") was recognized early when, after only two years at Furman, he became the first recipient of the Alester G. Furman and Janie Earle Furman Meritorious Teaching Award. The American Psychological Association recognized him with their Award for Distinguished Teaching in Psychology in 1989 and the Award for Distinguished Career Contributions to Education and Training in Psychology in 1995. More than 100 of Brewer's former students have earned doctorates in psychology.

Furman's Reserve Officers Training Corps (ROTC) began in 1950 and was compulsory for all able-bodied male freshmen and sophomores until 1965. Since 1996, Furman's ROTC has been one of five programs invited to compete in the U.S. Military Academy at West Point's Sandhurst Competition, and in 1999 the Paladin Battalion placed first among ROTC units. In 2000, the department moved into the new Bryan Center for Military Studies, and was ranked 12th among ROTC programs nationally. Graduates of Furman's ROTC program include Vice-President for Student Services Harry Shucker and President David Shi.

Beloved history professor Bill Leverette left an indelible mark on generations of Furman students, including President David Shi, an eminent historian, and Assistant Professor of History Steve O'Neill. Family and friends established the William E. Leverette Jr. Professorship of History in his honor. Written on the board behind Dr. Leverette are the names of some well-known history faculty from decades past: Winston Babb, Edward Jones, Newton B. Jones, Delbert "Dr. Gilly" Gilpatrick, and Albert N. Sanders.

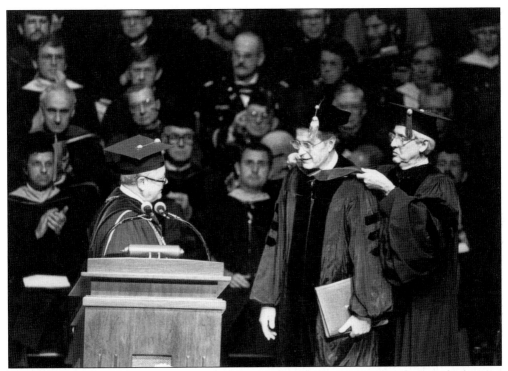

In 1983, Furman bestowed upon George H.W. Bush an honorary Doctor of Laws when the vice-president spoke at convocation.

Also known as the bionic man, Health and Exercise Science Professor Sandor Molnar frequently wore t-shirts that read, "The Optimal Man," and could be seen every morning on the mall stretching and exercising, often with a group of students surrounding him. Molnar challenged students every year to join him in "conquering" Paris Mountain with a 4.4-mile run starting in the PAC Circle and ending at the top of the mountain. When Molnar died in 1987, the HES department organized the Molnar Memorial Mountain Challenge, held on the study day of spring term every year. In 2002, the Molnar Challenge evolved into the Molnar Memorial Fitness Challenge.

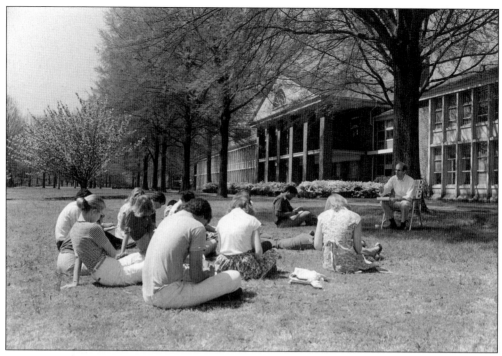

Furman professors frequently take classes outside on beautiful days. Here, History Professor Bill Lavery's class meets outside of Furman Hall in the early 1980s. Lavery, a specialist in Russian history and culture, heads the Center for International Education.

The American Chemical Society has cited the chemistry department as a model for other undergraduate departments. Furman is consistently ranked in the top-10 among undergraduate colleges in the country that produce Ph.D. candidates in chemistry, and in the top-25 of undergraduate chemistry programs that graduate students certified by the American Chemical Society. Furman's summer chemistry research program, which annually engages dozens of students in original and publishable quality research with Furman chemistry faculty, is the largest undergraduate-faculty research program in the country. In this photo, Rose J. Forgione Professor of Chemistry Moses Lee instructs a student in the lab.

Dr. Bingham Vick has conducted the Furman Singers since 1970. In 1974, the singers embarked on a concert tour to Europe; biennially, this tradition continues. On their 1990 trip, the Furman Singers became the first choir to perform in the Russian Orthodox Cathedral of the Assumption inside the Kremlin in Moscow since 1917, the last year of tsarist rule before the Bolshevik takeover. In this 1996 photo, the Furman Singers perform with the Boston Pops, under the direction of alumnus and Maestro Keith Lockhart '81, on national television for the Pops' Annual Fourth of July Celebration. Lockhart, who double majored in music and German while at Furman, is the third person to lead the Pops since 1930, and follows legendary conductors Arthur Fiedler and John Williams.

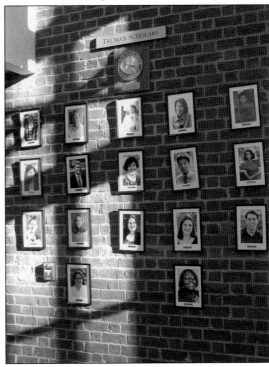

Furman is a national leader among liberal arts colleges for the number of graduates who have been awarded Truman Scholarships. Seventeen students have been awarded these scholarships since 1981. They include Eric Spitler '81, Lewis Gossett '87, Marylee James '87, Cass DuRant '89, Lisa Stevens '90, Tomiko Brown '92, Brian Cromer '92, Amy Powers '92, Chong Lo '93, Carey Thompson '94, Beth Dotson '99, Ginger Denison '00, Jenny Lambert '01, Adair Ford '02, Hal Frampton '02, Arianna McClain '02, and Monica Bell '03. (Courtesy of Charlie Register.)

Established in 1997, the Christian A. Johnson Center for Engaged Learning promotes education through active learning, research, internships, service learning, and technology. This invigorating approach to undergraduate education has garnered national attention; in 2003, Furman was ranked fourth (behind MIT, the University of Michigan, and Stanford) among U.S. colleges and universities in *US News and World Report*'s "Undergraduate Research/Creative Projects" category. In this photo, the Charles E. Daniel Memorial Chapel and Paris Mountain can be seen in the background of an on-campus banner heralding engaged learning. (Courtesy of Courtney Tollison.)

Since the program's inception in 1995 under the direction of Political Science Professor Glen Halva-Neubauer, Furman's mock trial team has been consistently ranked among the best undergraduate programs nationally. Furman teams have participated in the national championship tournament every year since 1997, and in 2002–2003, Furman was the only university in the country to have two teams ranked in the top-ten nationally. Furman students have captured the titles of all the nation's major invitational tournaments. Team members pose with their trophies after Furman's first appearance at the National American Mock Trial Association Championships in 1997. From left to right are Alice Morrison, Liz Herre, Coach Glen Halva-Neubauer, Ph.D., David Koysza, Coach Tim Hurkley, Ph.D., Matt Holson, Lauren Matthews, and David Coe. (Courtesy of Elizabeth Herre.)

Participants in the 1997 fall term in England program pose for a photo in Belgium. (Courtesy of Elizabeth Herre.)

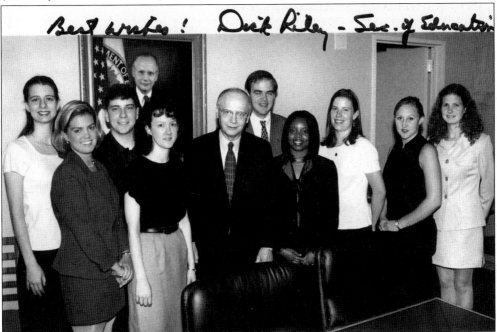

The Department of Political Science's Washington Program, which began in 1980, is a popular spring-term and summer option. Participants in 1999 meet with alumnus Richard W. Riley '54. A 1992 Clinton appointee, Riley served as U.S. secretary of education, and his term of service as secretary of education is the longest in the nation's history. From left to right are Natalie Byars, Carrie Smith, Craig Hunter, Dr. Danielle Vinson, Dick Riley, David McDowell, Michelle Reid, Ansley Campbell, Jeny Bishop, and Cara Hodges. (Courtesy of Ansley Campbell.)

The Richard W. Riley Institute of Government, Politics, and Public Leadership was established in 1999. Speakers, conference participants, and lecturers in residence have included law professor and environmentalist Robert F. Kennedy Jr.; former Secretary of State Madeleine Albright; U.S. Senator Hillary Rodham Clinton; Marian Wright Edelman, founder of the Children's Defense Fund; James Lilley, former ambassador to China and the Republic of Korea; and CBS News' *60 Minutes* co-host Lesley Stahl. On January 29, 2004, the institute hosted a nationally televised Democratic Party Presidential debate moderated by NBC News Anchor Tom Brokaw. Political Science Professor Don Gordon is the institution's first director. Here, former First Lady and Senator Hilary Rodham Clinton accepts Furman gifts from Dee Dee Corradini, former mayor of Salt Lake City, Utah, and in residence at the Riley Institute. Below, Tom Brokaw talks with students in Burgiss Lounge while Dean Tom Kazee looks on.

Five

STUDENT LIFE

On the Hill, at the Zoo, and in the Bubble

From intramural sports and volunteer opportunities to religious groups, special-interest clubs, and Greek-letter organizations, Furman students enjoy boundless options outside the classroom.

Extracurricular activities are vast; Furman has 8 fraternities, 8 sororities, 15 religious organizations, multiple political, performing arts, and ethnic and cultural groups, intramural and club sports, and organizations such as the Association for Furman Students (AFS) and the Furman University Student Activities Board (FUSAB). The Paladin, *Furman's student newspaper, is popular, and* Echo, *an annual student literary magazine founded in the late 1800s, publishes student poetry and art. The majority of students volunteer locally as members of the nationally recognized Max and Trude Heller Collegiate Educational Service Corps, founded in 1965. Beach Weekend, an annual tradition, is a popular event before spring-term exams.*

When Furman and the Greenville Woman's College merged in 1933, and when both campuses united on the current campus in 1961, some traditions were lost, others gained. Student life has changed. The "Furman Bubble" has replaced the "zoo" and the "hill." Pre-game parades no longer march down Main Street in Greenville, but down Milford Mall. The Hornet, Furman's student newspaper, became The Paladin. Chapel attendance is no longer required, classes no longer meet on Saturdays, and on campus dances and fraternities are no longer banned. The "Pala-den" staff now includes several Japanese sushi chefs, and the Tower Cafe Starbucks ensures that a latte is never far.

Other aspects of student life remain consistent, however. Students and faculty become friends, and the Bell Tower chimes, as it has since the 1850s.

During the Civil War, most students volunteered for military service, and Furman closed from 1862 to 1865. A corps of students and faculty formed an infantry unit and fought under this flag, the Battle Flag of the University Riflemen.

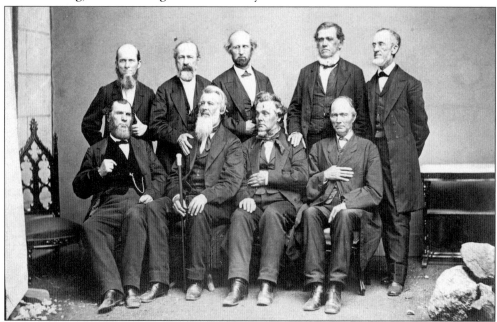

Furman graduates served as delegates representing their home states of Alabama, Florida, Georgia, and South Carolina at the Southern Baptist Convention meeting in Macon, Georgia, in May 1869. Standing left to right are R. Furman, W.J. Hand, J. Reynolds, W.J. Harley, J.C. Furman; seated left to right are W.H. McIntosh, James Furman Dargan, J.H. Defolie, and W.B. Cooper.

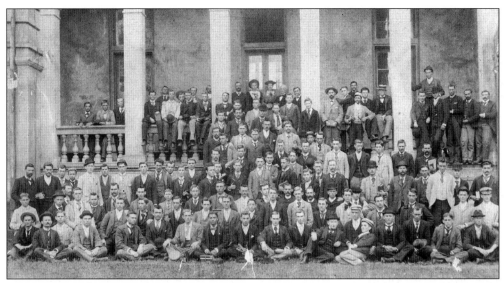

Furman's student body was photographed in the fall of 1893 on the north side of Old Main. The top middle five are, from left to right, Gordon B. Moore, professor of psychology; Margaret A. Brunson; the daughter of Dr. Manly; Charles H. Judson, professor of mathematics; and Charles Manly, president. President Manly supported the matriculation of women into Furman's student body for several years in the 1890s. Brunson and Manly were two of a handful of Furman's first female students. Brunson received an M.A. in 1896. From 1900 to 1932, no women attended Furman.

Furman University,

GREENVILLE, S. C.

.&. .&.

Next Session Opens September 25, 1901

.&. .&.

Full AND THOROUGH COURSES are given leading up to the degrees of M. A. and B. A. Expenses are low. A splendid dormitory is now in process of erection—will be completed for occupancy next session.

For further information, apply to

A. P. MONTAGUE, Ph. D., LL. D., President,

Or A. H. MILLER, A. M.,
Secretary of the Faculty.

Greenville Female College,

GREENVILLE, S. C.

.&. .&.

Location.—Blue Ridge section ; beautiful and unsurpassed in healthfulness. Invigorating climate, free from malaria. Pure water from Paris Mountain, 2,000 feet above the sea.

Buildings.—Repainted and renovated. Every music room a parlor. A new building is being added for Lecture Rooms, Auditorium, Dining-room, Dormitories, etc.

Curriculum.—Full collegiate and special studies of Music, Art, Elocution, Pedagogy, Stenography, Typewriting, etc.

Faculty.—Expert teachers, selected for technical skill, moral worth, Christian devotion, and social excellence. Classic music taught by experienced and distinguished director educated in America and Germany. Individual attention.

Applications for rooms should be made in advance. Several have already applied (April 24). From present indications, the building with its large new addition will be filled.

For catalogue address

E. H. MURFEE, President.

As the above advertisement in the 1901 Greenville Female College yearbook, then known as *Blue and Gold*, indicates, Furman and the Woman's College, both under the auspices of the South Carolina Baptist Convention, had maintained a close relationship since the founding of the women's institution in 1854.

Alma Mater

We now call thee Alma Mater,
Oh, the music in those words!
How they fill our hearts with gladness,
Banish every thought of sadness,
And bring memories fond and dear
 To thy loyal daughters.

Thou hast ever, Alma Mater,
Been our Light and Leader true;
Thou has shown o'er pathways dreary,
Led us on, though steps were weary,
Till with vict'ry thou didst crown us
 Thine own loyal daughters.

Ever will we, Alma Mater,
Sing thy praises far and wide;
Thou hast been a fair, wise mother,
And we'll love thee as no other;
But through all the coming years,
 Be thy loyal daughters.

As we go, dear Alma Mater,
Forth to battle on life's field,
We will keep thy banner o'er us,
With thy love and truth before us,
Thoughts of thee will keep us brave
 And faithful, loyal daughters.

—BERNICE M. BROWN.

Some traditions, however, were nevertheless lost in the coordination between GWC and Furman, such as the women's college alma mater, which appeared in the 1912 *Entre Nous*.

This group of Furman students kept themselves entertained with cigars and cards while quarantined with scarletina in 1906.

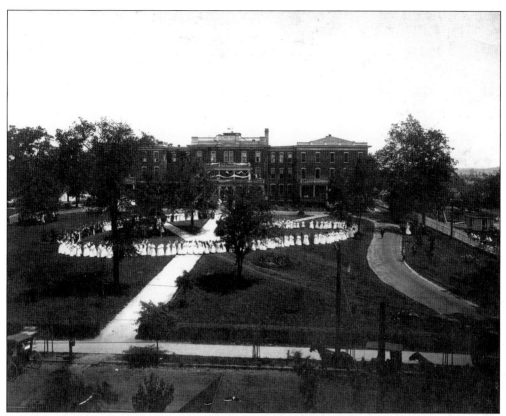

May 15, 1908 was College Day at Greenville Female College.

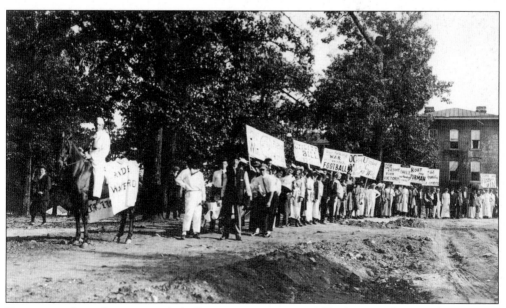

Furman students form a parade before a game against Wofford in October 1914.

The Greenville Woman's College Class of 1930 poses for a photograph.

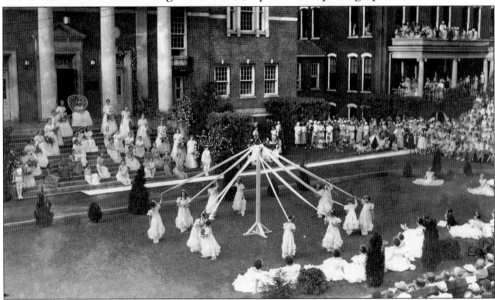
May Day, a favorite tradition on the women's campus, began in 1837 at the Greenville Female Academy. May Day festivities were held on the new campus as well, but stopped in the early 1960s. In 1967, Betty Alverson developed May Day Play Day, a new kind of tradition focused on social service. The 1936 May queen, her court, and the crowd direct their attention to the May Pole in front of the David Marshall Ramsay Building of Fine Arts.

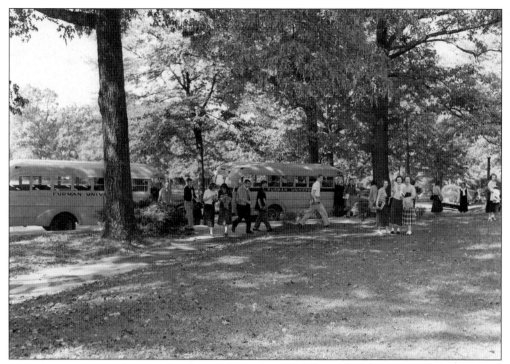

After the merger, students at the Greenville Woman's College and Furman took coed classes on both campuses. Initially, yellow taxis transported students between the women's college, or "zoo," and Furman, known as "the hill." Here, women rush to catch Furman buses for class.

Mid-century students at Greenville Woman's College play in the snow. (Courtesy of Greenville County Historical Society.)

Dr. John Laney Plyler buys the first War Bond from Marilyn Miller as part of a drive sponsored by the business staff of the *Hornet*.

From left to right, Marnie Simone, Mary Ellen Schuamann, and Mary Francis Davis sit in the Browsing Room on the GWC campus, *c.* 1944. The women's dorms on the new campus have similar spaces.

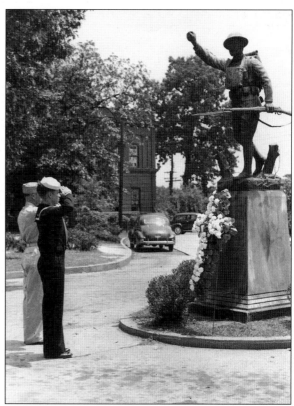

Male student enrollment dropped dramatically during World Wars I and II. This life-size copper "doughboy" statue of a soldier running to battle was erected on the circle behind the library on the downtown campus in 1921 to commemorate the lives of the six students who died in World War I. Five hundred and forty Furman men volunteered for service during World War I. After World War II, in which the overwhelming majority of Furman males similarly volunteered for service, the Class of 1947 added a plaque to honor the dead from that war. In 1957, Furman transported the doughboy from the old campus to the traffic circle just south of the lake. In 2004, the doughboy was refurbished in bronze and moved near Paladin Stadium.

Rats Reggie Graham and Dotty Greene experience the rituals of freshman hazing.

Homecoming festivities still include a bonfire the evening before the big game, as they did at mid-century.

The men and women of the sophomore class created a monument to their history for homecoming in October 1955.

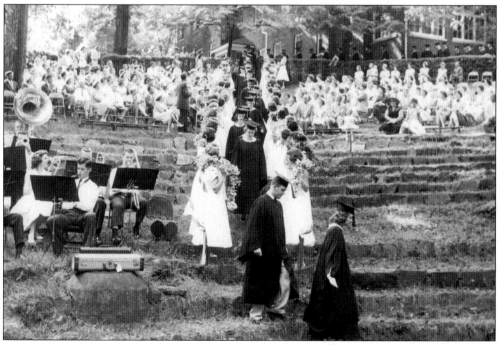

One GWC tradition that continued after the merger with Furman was Class Day exercises, in which sophomores strung daisies together to create a path for the graduating seniors. Class Day festivities were day-long events held in the spring just before graduation.

At mid-century, the Baptist Student Union attracted the majority of students into membership. This meeting was the first for the 1954–1955 academic year. Notice the rat caps on the freshmen.

The 1962 *Bonhomie*, the first since the move to the new campus, captured the significance of the 1961–1962 academic year: "What it has been in the past, what it is now, and what it will be in the future, no longer a house divided—for the first time in history, Furman men and women are united on one campus." Here, male and female students study and socialize in the evenings downstairs in the new library; this area served as the primary social spot in the early 1960s, as the student center was not completed until 1965. Popular gathering spots for students on the downtown campus included the library steps and the concrete block "F," a gift of the Class of 1928.

The Paladettes, a drill team that performed at halftime of football games in Sirrine Stadium, were photographed in 1965.

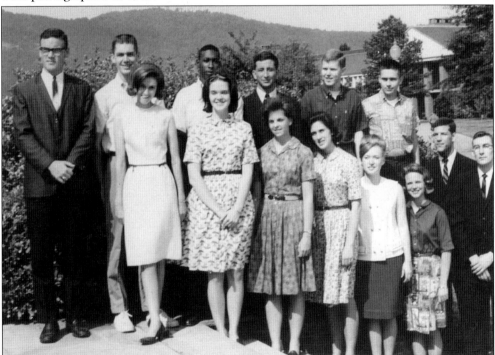

Ironically, Furman's first African-American student, Joseph Vaughn, was an officer in Furman's Baptist Student Union (BSU). BSU was an organization under the auspices of the South Carolina Baptist Convention, the organization that tried to keep Vaughn from attending Furman. As early as 1954, however, BSU students spoke against the SCBC's reactions to changes in race relations. Vaughn was also a cheerleader, vice-president of the Southern Student Organizing Committee (SSOC), and a CESC volunteer. Vaughn is photographed here with fellow BSU officers in the late 1960s. In 1992, the year after Vaughn died, family and friends established a scholarship fund in his memory.

Students in the 1960s began a new tradition for a new campus: hallmates recognizing birthday celebrations, engagements, and any other special occasions with a celebratory dunk for the honoree in Furman's lake, a tradition that continues today. Even President Blackwell was thrown in!

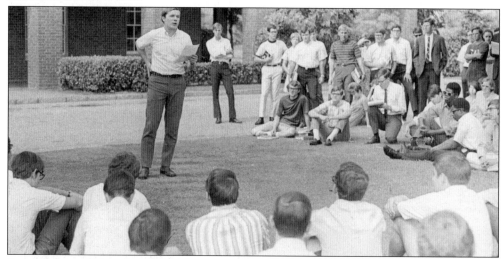

Furman's small but vocal Southern Student Organizing Committee (SSOC) gathered support among students and enacted fundamental changes in student life. In 1968, Joe Vaughn and other SSOC members organized marches in downtown Greenville after the Orangeburg massacre and Martin Luther King's assassination. SSOC members led the movement against mandatory chapel, which administrators repealed in the fall of 1969. Here, about 150 students gathered on March 29, 1969, at a rally outside the administration building and expressed their concern regarding the speaker ban that the administration had imposed the year before in an attempt to avoid the on-campus disturbances taking place at colleges and universities around the country at the time. SSOC president Jack Sullivan addresses the crowd. Other speakers included John Duggan, student body president Ron McKinney, Fran Jackson, and professors A.V. Huff, Tony Arrington, and Bill Lavery. Although Dr. Blackwell did not support all of the demands of the student movement, he listened to students' opinions and defended their right to protest.

Furman students hold a candlelight vigil on May 5, 1970, the evening after the Kent State riot. On October 21, 1971, Vietnam Veterans Against the War leader John Kerry spoke on campus.

Each year at halftime of the homecoming football game, a senior woman elected by the student body is crowned homecoming queen. Here, Susan Thomson (Shi), *cum laude* graduate, student body officer, CESC volunteer, and member of the President's Advisory Council and Senior Order, is Furman's 1970 homecoming queen.

Members of Association of Furman Students (AFS), the Max and Trude Heller Service Corps (CESC), and the Student League for Black Culture (SLBC) join freshman advisors (FRADs), resident assistants (RAs), and the orientation week staff in developing a freshman and new student orientation program that serves as a national model for other colleges and universities. Organized by Carol Daniels '82, orientation week activities quickly quell freshman nervousness. Here, freshmen talk with President Blackwell at the president's picnic at the Blackwell's home during orientation week.

Don't drop the Life Saver! This orientation week game has been around a while.

At the 1987 freshman orientation, Dr. and Mrs. Johns and Dr. Harry Shucker, vice-president for student services, greet students. Before the president's picnic, each freshman hall's advisors, or FRADs, organize games that result in pairings between individuals on brother and sister halls. The brother hall collectively arrives, roses in hand, to pick up their dates.

The long lines on registration days and the colorful stamps that validated Palacards are no more! Now, everything is digital.

Furman's Collegiate Educational Service Corps (CESC) is one of the largest collegiate volunteer organization in the country. CESC was founded in 1965 by Betty Alverson '57, better known as "Miss A," with help from Alverson's former professor Laura Ebaugh, a sociology professor whose students, under her guidance, worked in local hospitals, community centers, schools, and courts. CESC students have continued this work, volunteering weekly in local schools, homes for the elderly, and dozens of social service agencies. Two of CESC's more popular end of the year events include a senior prom for those in a local nursing home and May Day Play Day, where everyone who has benefited from a CESC program that academic year is invited to campus for a full day of fun. CESC has been recognized twice as one of the top four volunteer programs in the country; about 60% of Furman students participate in CESC each year. In 2002, CESC was renamed the Max and Trude Heller Collegiate Educational Service Corps in honor of the Heller's civic leadership, and decades of involvement with Furman and CESC. Here, student CESC director Lindley Sharp speaks while the Hellers look on.

With every blizzard comes a snow fight in the South Housing quad!

102

This student just can't wait for Beach Weekend!

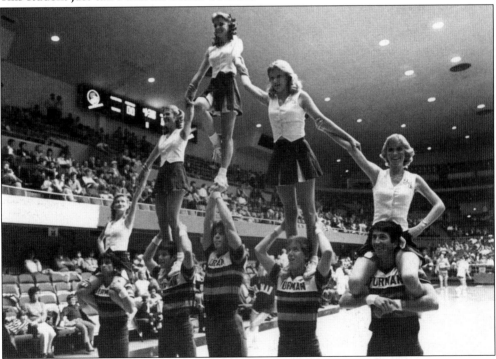

Furman cheerleaders perform a stunt at a basketball game at Greenville Memorial Auditorium in the early 1980s. They are, from left to right, Cathy Cassons, Beth Jones, Renee Deinzer, Michele LeForce, and Tracey Bullew; (on the bottom) Eddie White, Bob Davis, Trey Massey, Stuart Pratt, and Mark Sanford. Sanford '83 was elected governor of South Carolina in 2002.

Founded in 1903, Quaternion is a self-perpetuating and highly-selective honorary society. In 1910–1911, when the one remaining Old College building faced destruction, Quaternion petitioned to save it, hoping to take charge of the building's maintenance and use it as meeting space. Ever since, the small handful of men who are chosen from each class are given a key to the building, located near the Bell Tower circle. Prominent members include John Plyler, Gordon Blackwell, John Johns, Richard Riley, Frank Selvy, Darrell Floyd, and David Shi. The women's equivalent of Quaternion is Senior Order, founded in 1937 by Dean of Greenville Woman's College Virginia Thomas. Each year, 15 women are chosen in the spring of their junior year to become members.

Here, students in the 1980s meet for Bible study in the parlors in the Lakeside Housing complex. Since Furman disaffiliated from the South Carolina Baptist Convention, the university has honored its Christian heritage in myriad ways. Spirituality flourishes on campus, as is evidence by the vitality of the 15 religious organizations.

The history of Greek organizations at Furman has been erratic. Since the mid-1800s, fraternities have battled state laws and lack of support from the Baptist Convention. Local fraternities, such as Centaur, The Knights Eternal, Cygnus, and Star and Lamp, regained their national charters in the mid-1980s by skirting the Baptist Convention's ban. Each spring, the Mallory Reynolds Smith Trophy is presented to that fraternity that contributes most to the academic, athletic, religious, and student life of the university. Sigma Alpha Epsilon, Pi Kappa Phi, Sigma Nu, and Tau Kappa Epsilon have each won multiple years. A group of Sigma Chis gathered for a group shot at a Christmas formal in 1996.

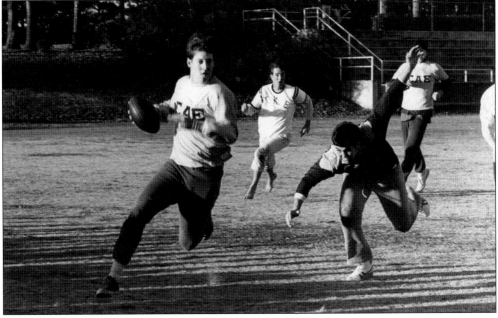

Here, TKEs and SAEs play a game of intramural football.

ALPHA DELTA PI
Furman University
Black Diamond Ball 1997 *Classic Photo Inc.*

Greenville Female College students established local sororities in 1911. GWC Pan-Hellenic voted to nullify themselves in 1936, however, after the administration passed a law prohibiting students receiving any financial aid from membership. In the early 1980s, students founded local sororities. The first three were VIDA, Delphians, and Theta. Although these young women did not believe, because of Baptist opposition, that they could one day become national sororities, they nevertheless needed guidance in the establishment of bylaws, and each group loosely used a national sorority as their guide. In 1994, Furman's local sororities became national. Eight sororities exist on campus: Alpha Delta Pi, Alpha Kappa Alpha, Chi Omega, Delta Delta Delta, Delta Gamma, Delta Sigma Theta, Kappa Delta, and Kappa Kappa Gamma. In this "snappy," Alpha Delta Pis from the Class of '99 gather at their Black Diamond Ball in the spring of 1997. (Courtesy Classic Photo, Inc., www.classicphotoinc.com.)

Pictured here are the 1998–1999 Furman University Danzers in their warm-up area in Timmons Arena before the last basketball game of the season. The Danzers, an outgrowth of multiple dance groups that have preceded them since 1964, assumed its name in 1998. Danzers perform at football games and at halftime of basketball games. From left to right are as follows: (top row) Robyn Brewer, Laura Nations, Heather Shuping, and Jessica Sumner; (middle row) Kristy Rediehs, Katie Gamble, and Katie Sweeney; (bottom row) Courtney Tollison and Courtney Armstrong. (Courtesy of Courtney Tollison.)

On the chapel steps on September 11, 2002, students held an all-night vigil honoring the Duncan Chapel Fire Department and in memory of those who died on September 11, 2001. (Courtesy of Charlie Register.)

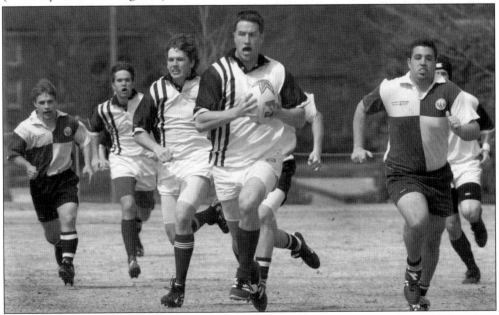

In addition to its very popular intramural sports program, Furman has developed an extensive club sports program in recent years. Equestrian, men's and women's lacrosse, and men's and women's rugby, among other club programs, compete against club teams from other colleges and universities. In 2003 and 2004, men's rugby teams won the Rugby South Division III and East Coast Division III championships. Here, the men's rugby team plays the University of Alabama during the 2003-2004 academic year. (Courtesy of Charlie Register)

The women of Blackwell 200 North, also known as the Soda Pops, are ready for the freshman's annual "My Tie" dance near the end of orientation week. Shown here on September 12, 2003, are, from left to right, (front row) Natalie Nerland, Dee Jackson, Sara Jones, Melissa Kempton, Elizabeth Stoioff, Liz Roach, Lauren Vann, and Colleen McCormick; (back row) Johanna O'Brien, Tia Sullivan, Lauren Ourt, Kara Bailey, Jane Wood, and Guinn Garret. (Courtesy of Johanna O'Brien.)

Members of the Class of 2007 studied outside the University Center Tower Café Starbucks. Bordering the lake with an unobstructed view of the Bell Tower, this area is a popular gathering spot for students. Clockwise are Floyd Stanley, Caleb Rutledge, Ashley Sisco, Michelle Hooper, and Katie Lewis. (Courtesy of Courtney Tollison.)

Six

FURMAN ATHLETICS

F.U. All the Time!!

Since the organization of the first varsity athletics team in the late 1800s, Furman University has fostered national championship football and women's golf teams, scores of All-American, All-Conference, and professional athletes, and countless conference championships. Intercollegiate football began at Furman in 1889, intercollegiate baseball in the mid-1890s, and intercollegiate basketball in the 1908–1909 academic year.

Most programs have continued uninterrupted. Although Furman played with an undermanned football team in 1942, the absence of a substantial percentage of the male student body due to World War II resulted in a moratorium on varsity football, basketball, tennis, and track for the duration of the war. In 1936, Furman became a member of the Southern Conference, which brokered a Division I-AA football designation in 1981.

University historians debate the origins of Furman's colors. The earliest recorded appearances of the colors, royal purple and white, are reported from Furman's first football game in 1889, when the team played in purple-and-white "caps," and the 1892 football game against the University of South Carolina, with players donning striking purple-and-white uniforms.

Although united under these colors, Furman teams played under different mascots until a 1961 student-body vote united all teams under the "Paladins." At football games, a knight on horseback in medieval armor leads the team onto the field and cantors along the sidelines each time Furman scores—a definite crowd pleaser.

Furman supports 17 varsity, 20 intramural, and 13 club sports. Notable Furman athletes include basketball stars Frank Selvy and Darrell Floyd, football standouts Stanford Jennings and Sam Wyche, PGA golfer Brad Faxon, LPGA golfers Betsy King, Beth Daniel, and Dottie Pepper, and swimmer and Olympic medalist swimmer Angel Myers Martino.

In 2002, Sports Illustrated *named Furman one of the country's top-100 "Best Sports Colleges." In 1991, the Southern Conference recognized Furman as the top men's athletic program when it awarded the university the Southern Conference Commissioner's Cup, and in 2004, Furman won the Germann Cup, an award that recognizes the college or university in the Southern Conference with the best women's sports program, for the 12th consecutive year.*

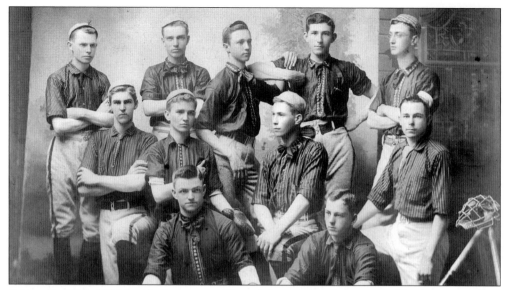

Furman's 1893–1894 baseball team are, from left to right, (front row) Ellis Stuart, pitcher; and Lonnie Mattison, catcher; (middle row) T.A. Quattlebaum, third base; McNeill, shortstop; Lipscomb, second base and captain; and B.K. Truluck, first base; (back row) Watson, field; Burton, field; Lott, Ben Holland; George Baker, field. By 1902, this uniform had been abandoned, and players wore dark purple jerseys with "Furman" across their chests in white.

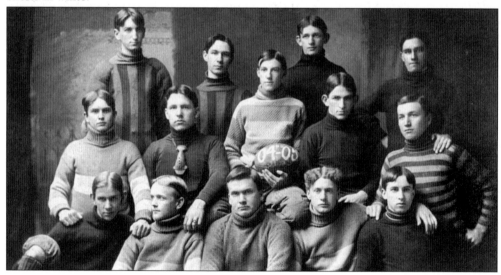

The first intercollegiate football game in South Carolina occurred when Furman team captain Tom Rogers issued a dare to Wofford College's team. The game, played on December 14, 1889, ended with a Wofford victory. J.E. Sirrine also played on that team, and at the golden anniversary celebration of intercollegiate football in 1939, he recalled that the teams played with no uniforms, no positions, and only the few regulations the teams agreed to before they initiated play. Pictured here is Furman's 1904–1905 football team. From left to right are (front row) James Crawford Keyes, L.L. Rice, S.E. Boney, and Clement Furman Haynsworth; (middle row) unidentified, J.E. Lipscomb, Thomas Ealre Mauldin, and A.J. Gregory; (back row) Cantwell Faulkner Muckenfuss and Addison Malcolm Scarborough

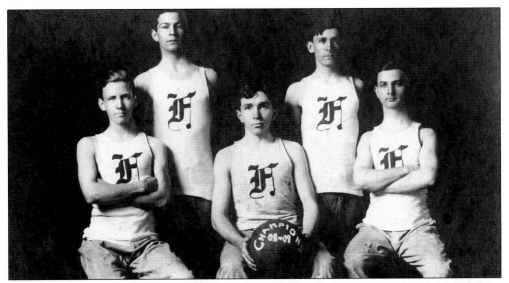

Pictured here is Furman's first basketball team, 1908–1909. They are, from left to right, (seated) Gordon Poteat, Maxcy White, and Norman Fender; (standing) Gene Milford and R.A. McDowell. The Southern Conference's basketball tournament, the oldest in college basketball, began in 1921, and Furman's 1922 and 1923 teams qualified for tournament play. Furman returned to tournament play in the 1950s.

Furman dominated football in South Carolina throughout much of the 1920s and 1930s under Coaches Lawrence "Billy" Laval and Archie Paul "Dizzy" McLeod. The "Purple Hurricane" won the fabled state championship (against rivals The Citadel, Clemson, Erskine, Newberry, Presbyterian, and the University of South Carolina) for the 1924, 1925, 1926, and 1927 seasons. During the 1920s, Furman teams beat North Carolina State and the Universities of Florida, Georgia, Mississippi, and Virginia, among others. Pictured here is 1920s standout player H.R. "Red" Dobson '25, who was All State, All-Southern Intercollegiate Athletic Association, and the most valuable player on the team in 1924. After several varsity athletic programs resumed after World War II, Red Dobson became Furman's athletic director; he was a 1982 inductee into Furman's Athletic Hall of Fame.

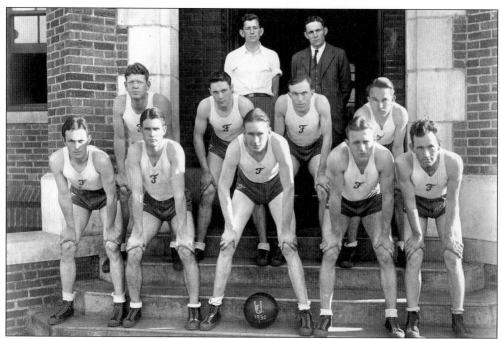

Greenville News Sports Editor Carter "Scoop' Latimer first used the phrase "purple paladins" in February 1927 to describe Coach Laval's basketball team in the midst of their successful season. Throughout the 1930s, Latimer began using the phrase "purple dervishes" for Coach McLeod's teams, but in the 1940s, the team became known again as the "paladins." Here, Furman's basketball team is photographed in 1930.

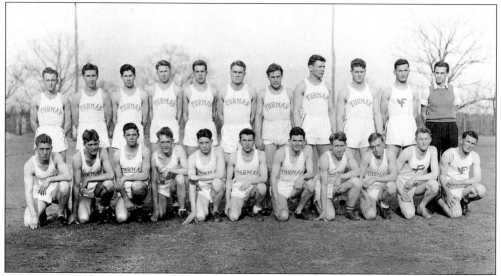

Furman's track team is seen here in 1936–1937. Men's and women's track and field and cross-country teams have won seven Southern Conference titles and six Southern Conference Cross-Country Team Championships. Furman dedicated the Irwin Belk Complex for Track and Field and the Kelsey-West Track in 1997. Longtime coach Gene Mullin, who began coaching duties at Furman in 1983, has won seven Southern Conference Coach of the Year Awards.

Furman and City of Greenville representatives dedicated Furman's new stadium, a joint venture named after alumnus J.E. Sirrine, on November 14, 1936, in a game against the University of South Carolina; Furman won 23-6. Furman finished the 1936 season with a 7-2 record and won the state title, its last, as Furman was admitted to the Southern Conference in 1936. In this photograph, buildings on Greenville's Main Street are visible behind players on the 1936 team.

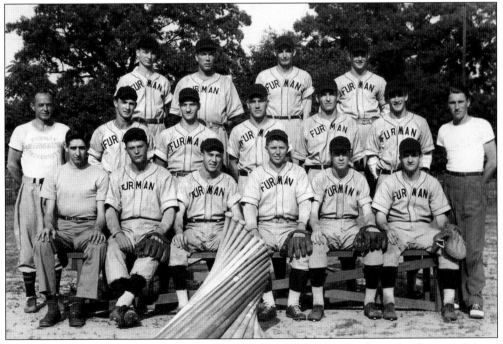

Although Furman fielded a team as early as the late 1800s, the Southern Conference did not include baseball among its sports until 1947. The 1948 team, pictured here, defeated all other colleges and universities in South Carolina that spring.

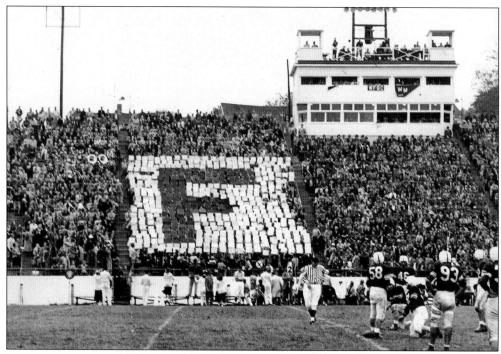

Fans created an "F" in the stands during this football game in Sirrine Stadium in 1950.

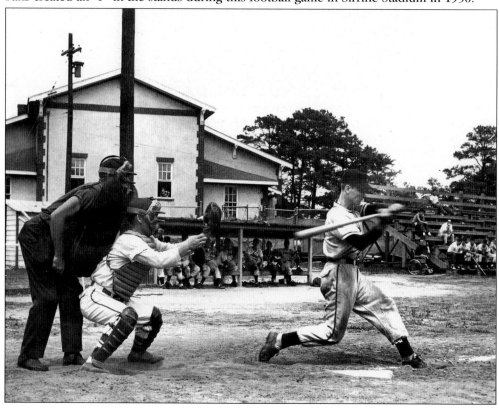

Furman plays in a 1952 game on its home field at Furman's downtown campus.

Known at Furman as "The Man," Furman's most well-known athlete, Frank Selvy, became the first player to score 100 points in an NCAA Division I game, a feat since unmatched. The best basketball player in the country at the time, Selvy set this record before a crowd of more than 4,000 in Textile Hall during Furman's victory over Newberry on February 13, 1954. Forty feet from the basket, Selvy's one-handed, 100th point sailed in as the buzzer sounded. Selvy was the first player in NCAA history to score an average of more than 40 points per game and to score more than 1,000 points in a season (Selvy finished with 1,209). Because of the public's intense fascination with Selvy, who ranks second to Pete Maravich in points per game in NCAA history, this game was the first college basketball game televised in South Carolina. A three-time All American, Selvy led the nation in scoring during the 1953 and 1954 seasons, and was named Southern Conference Athlete of the Year and United Press International National Player of the Year. The NBA's Baltimore Bullets chose Selvy first in the draft and paid him the highest salary ever paid a rookie at that time. Selvy played for the Milwaukee (later St. Louis) Hawks, and, after several years stationed in Germany with the U.S. Army, he played with the New York Knicks and the Minneapolis and Los Angeles Lakers. While at Furman, Selvy's exploits created an enthusiasm on campus absent since the glory days of Furman football in the 1920s and 1930s and brought national attention to Furman. Off the court, Selvy excelled as well; Selvy was senior class president, a member of the Blue Key academic honor society, and elected into Quaternion. He is a member of the Kentucky Athletic Hall of Fame, South Carolina Hall of Fame, and charter member of the Furman Athletic Hall of Fame.

Darrell Floyd, one of Frank Selvy's teammates in 1954, helped maintain Furman's place as a basketball powerhouse in the 1950s. Floyd led the country in points per game in 1955 with 35.9 and in 1956 with 33.8; as a result, a Furman player led the nation in points per game for four straight years. No teammates have held back-to-back scoring titles since. Floyd's career points per game average is eighth in NCAA history. An All American in 1955 and 1956, Floyd played for the St. Louis Hawks. Floyd '56 is a charter member of Furman's Athletic Hall of Fame.

President John Laney Plyler threw out the first pitch at the dedication of the baseball diamond on Furman's new campus in 1957. As a student in the early 1910s, Plyler was a stand-out left-handed pitcher on the Furman baseball team and was offered a professional baseball contract. Mid-century Furman baseball teams had various successes: Jimmy Powell, a third baseman on the 1941 team, holds the university record for highest season batting average, with .432; and the 1954 team had two All-State players, Ross Sutton and Ted Yakimowicz. The 1965 team, the first to play in the university's 1,320-seat stadium, won the Southern Conference, as did the '69, '71, and '76 teams. In the late 1980s and early 1990s, Brent Williams set records with 17 home runs, 60 RBIs, and a slugging percentage of .732. He and his teammates won the 1991 Southern Conference tournament.

Until a September 15, 1961 student body vote decided to unite all sports team under one mascot, the "paladins," the football team was known as the "mountaineers" from 1892 to 1920 and then alternated between the "hornets" and the "purple hurricane;" the baseball team went as the "hornets;" and the basketball team, as the "purple paladins." The successes of Furman's men's basketball teams in the 1950s contributed to the popularity of the "paladins" as a universal rallying symbol. Here, "Mighty Sensation" trots around field's edge during a game in 1963.

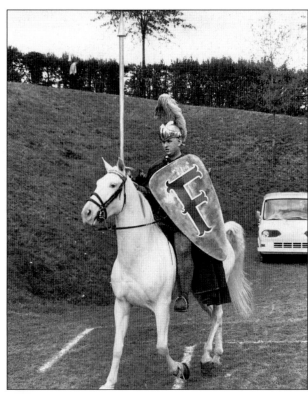

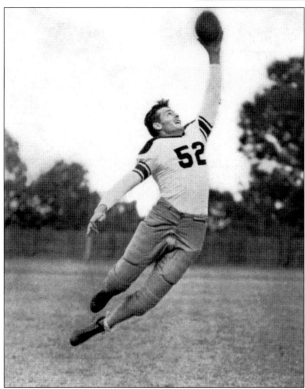

Bob King catches a football while a student at Furman University. King played on the 1936 team, which won the state championship. He was Furman's first All-Southern Conference selection and was honorable-mention All American. King served as an assistant coach under Dizzy McLeod before entering the military during World War II. Upon his return, he was an assistant coach at the University of Illinois. In 1957, he accepted the head-coaching position at Furman. Coach King was named South Carolina Coach of the Year twice. Under King, the Paladins were invited to play in the Tangerine Bowl in 1962, but declined. King '37 is a charter member of Furman's Athletic Hall of Fame.

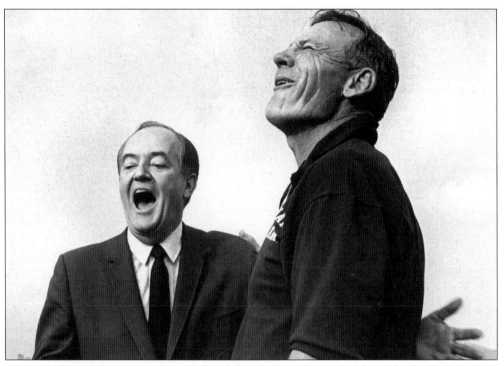

Vice-President Hubert Humphrey and Coach Bob King share a laugh on the football practice field during Humphrey's visit to the university in the late 1960s.

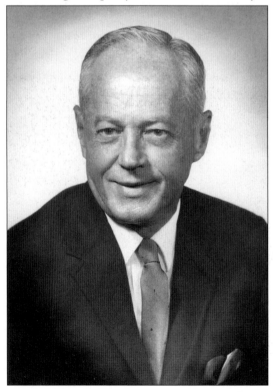

Lyles Alley '33 played on Furman's 1932 state championship team and was named All-State that same year. Alley served as an assistant football coach under Coaches McLeod and R.W. "Bob" Smith. Among his achievements as head basketball coach and athletic director are the basketball teams of the 1950s and the recruitment of tennis coach Paul Scarpa. With 223 wins, Alley ranks fifth among the winningest men's basketball coaches in the Southern Conference. The gymnasium in the athletic building on the downtown campus was named after Alley. Alley is a charter member of Furman's Athletic Hall of Fame and a 1987 recipient of Furman's Alumni Service Award. Furman annually presents the J. Lyles Alley Coach of the Year Award.

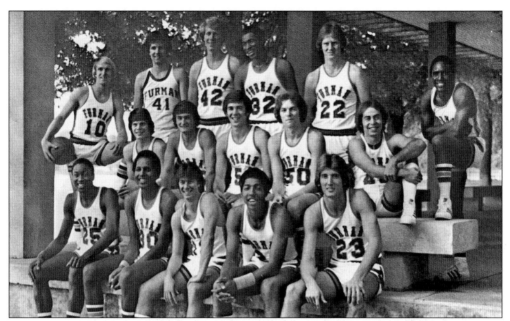

Furman's basketball program had great success in the 1970s and still holds the record for most points scored in a Southern Conference championship game (against VMI in 1972, they scored 126 points). Furman won the SoCon championship in 1974, 1975, and 1980, and shared the title in 1977 and 1991. Furman also holds two positions on the Southern Conference's list of the top-ten points scored in a championship game by a player: 36 by Roy Simpson in 1972 and 31 by Al Daniel in 1979. The 1977–1978 team (seen here at the Watkins Student Center), captained by basketball and baseball standout Ron Smith (Number 10), Furman's current baseball coach, beat Clemson, UNC, and NC State. Furman earned a berth in the NCAA tournament six times between 1971 and 1980, and played in the NIT in 1991.

Here, Beth Daniel '78, a member of the 1976 national championship team, swings while fellow future LPGA Hall of Famer Nancy Lopez (Tulsa) and Bev Davis (Florida) look on. Daniel and fellow Furman grad Betsy King '77, both LPGA Hall of Famers, organized the annual Furman Pro-Am, which has raised over $1.5 million for the Furman golf scholarship endowment. Daniel is a charter member of Furman's Athletic Hall of Fame, and in 1996 and 2001, Furman honored Betsy King and Beth Daniel, respectively, with the Bell Tower Award in recognition of their steadfast dedication to Furman.

Members of the 1976 National Collegiate Championship team under Coach Gary "Doc" Meredith include, from left to right, Cindy Ferro '76, Leigh Coulter '79, Betsy King '77, Beth Daniel '78, Holly Hunt '79, and Sherri Turner '79, four of whom joined the LPGA Tour after graduation. The women's golf team won straight Southern Conference championship titles from 1994 to 2002, and in 2004, Furman women golfers made their 14th appearance since 1983 at the NCAA Championship. Furman currently has the third-highest number of players on the LPGA Tour, behind Arizona State and the University of Texas. Furman's 1977 Athlete of the Year Betsy King is the first female player to reach the $6 million earnings mark and is a 1983 inductee into Furman's Athletic Hall of Fame. Fellow Furman teammate and LPGA Tour members Sherri Turner '79, along with LPGA players Dottie Pepper '87 and Jen Hanna '98, have also been honored with membership in Furman's Athletic Hall of Fame. The first nine holes of Furman's golf course were completed in 1957 when few colleges or universities had on-campus courses. Furman graduate Brad Faxon '83 plays on the PGA Tour and holds the course record with a 62. In 1997, Furman completed the REK Center for Intercollegiate Golf.

Sam Wyche '66 is the former head coach of the Cincinnati Bengals, whom he took to Super Bowl XXIII, and Tampa Bay Buccaneers. As a quarterback for Furman, Wyche passed for four touchdowns in a 1965 game, tying the university record. Wyche played for multiple teams in the NFL for more than 15 years and played in Super Bowl VII as quarterback for the Washington Redskins. Since his retirement from the NFL, Wyche has been an NFL analyst for NBC and CBS. Furman inducted Wyche into its Athletic Hall of Fame in 1983. He is currently a coach with the Buffalo Bills.

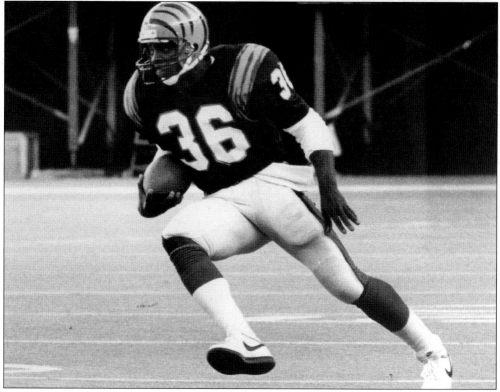

Stanford Jennings '84 holds the record for the fifth-longest kickoff return in the NFL with 93 yards. Jennings, who played for the Cincinnati Bengals under Wyche, is a 1990 inductee into Furman's Athletic Hall of Fame, and a Furman trustee.

Students, undeterred by the inability to take the Furman horse into Greenville's Memorial Auditorium for a basketball game, create their own.

The Paladins played their 1981 football season in a new 16,000 seat stadium. The existence of an on campus stadium returned football play to Furman's campus after nearly five decades of play in downtown Greenville's Sirrine Stadium. Here, President Johns speaks at the dedication of the Eugene E. Stone III Football Field in Paladin Stadium on September 14, 1985.

Under Coach Dick Sheridan, Furman football teams won eight conference titles, achieved a 69-23-2 record, and played for the national title against Georgia Southern in 1985. Sheridan left Furman to take the head-coaching position at NC State. Furman inducted him into its Athletic Hall of Fame in 1994, and in 2004, Sheridan was inducted into the South Carolina Athletic Hall of Fame. In 1985, the American Football Coaches Association (AFCA) awarded him coach of the year among Division I-AA institutions, an honor that would also be bestowed upon Jimmy Satterfield in 1988 and Bobby Johnson in 2001, making Furman the only college or university in the country to have three different coaches receive the award since the AFCA initiated the honor in 1935. Sheridan was head coach at Furman from 1978 to 1985.

Angel Myers Martino '90, a former Furman swimmer, won two gold and one bronze medal in the 1992 and 1996 Olympic games. For a time, Martino held the world record in the 100-meter backstroke, a record she set on December 3, 1997. In international all-time rankings of women's fastest recorded swim times, Martino is ranked 56th in 100-meter freestyle from the Olympic games in Barcelona in 1992; 65th in 50-meter butterfly from the Olympic trials in Indianapolis in 1996; and 78th in 50-meter backstroke from the Arena Festival Gala in Hamburg in 1993. Martino has also won four gold medals in the Pan American Games. She is a 1997 inductee into Furman's Athletic Hall of Fame. Furman's varsity swim program ended after the 1989–1990 academic year.

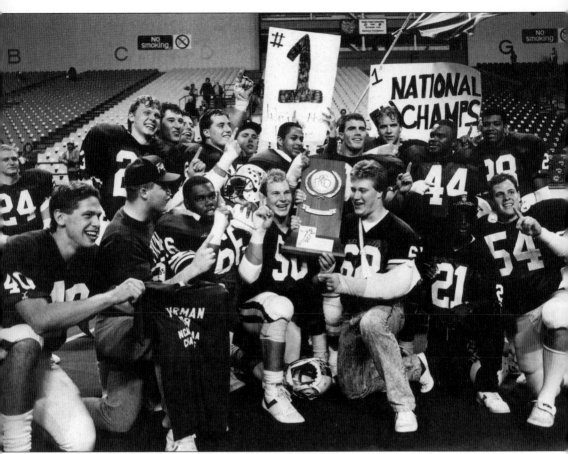

After losing to Georgia Southern in the 1985 championship game, Furman avenged its loss with a 17-12 win against the Eagles in Pocatello, Idaho, for the NCAA Division I-AA National Championship in 1988 under Coach Jimmy Satterfield. As a result, Satterfield was named Kodak and *Football News* National Coach of the Year. The championship team included two All Americans, the school's first consensus All American, one Academic All American, and nine All-Southern Conference selections. Much of Furman's football success in the last two decades of the 20th century must be credited to current Head Coach Bobby Lamb and to former Head Coach Bobby Johnson, who began his career at Furman as a defensive backs coach in 1976, and completed his master's degree at Furman in 1979. Johnson served as defensive coordinator at Furman under Sheridan and Satterfield, and in 1988, Johnson's defense led the nation in scoring defense, allowing only 9.7 points per game. During Bobby Johnson's eight years as head coach at Furman (1994–2001), the Paladins won two Southern Conference championships, went to the NCAA playoffs four times, beat the University of North Carolina 28-3 in 1999, and, in 2001, played for the national title against the University of Montana. Above, members of the 1988 championship team celebrate after their win.

Head Coach Bobby Johnson and Louis Ivory, the 2001 recipient of the Walter Payton Award, talk with reporters at a press conference at the National Championships in Chattanooga, Tennessee, in 2001. In Furman's 2000 football season, Ivory became the first player in the history of the Southern Conference to exceed 2,000 rushing yards in a single season.

Bobby Lamb '86 is pictured as Furman Football Quarterback in 1985. Lamb played quarterback in the national championship title game against Georgia Southern. He led the nation in Division I-AA pass efficiency. Lamb served as assistant coaches under Satterfield and Johnson. In 2002, Bobby Lamb joined a long list of Furman graduates, including Billy Laval, A. P. "Dizzy" McLeod, R.W. Smith, and Bob King, who have also served as head football coach. Lamb was a 1995 inductee into the Furman Athletic Hall of fame. Lamb heads a program with a strong legacy; Furman teams have won Southern Conference Championships in 1978, 1980, 1981, 1982, 1983, 1985, 1988 (tie), 1989, 1990, 1999 (tie), and 2001. Furman leads the Southern Conference in the number of conference football championships won.

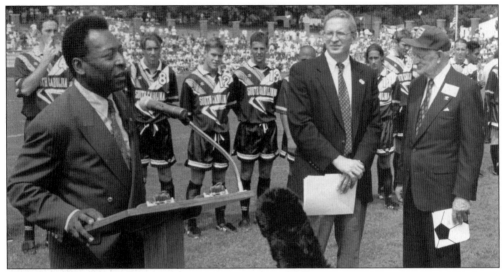

Pele, arguably the world's all-time greatest soccer player, speaks at the dedication of the 3,000-seat Eugene E. Stone III Soccer Stadium in September 1995 as Dr. Shi and Eugene E. Stone III look on. A longtime supporter of Furman athletics, Stone was the founder of Stone Manufacturing Company in Greenville. The stadium, surrounded by a brick and wrought iron fence, is considered one of the finest in the nation. Under Coach Doug Allison, Furman soccer standout Pete Santora became Furman's first All-American men's soccer player in 1996, an accolade he earned again in 1997. Furman's men's soccer won six straight conference titles and is ranked fourth in all time NCAA records for its string of undefeated games. Furman's 2002 freshman recruiting class was ranked third in the country, and between 1998 and 2002, Furman's men's soccer finished in the top 25 nationally.

Paul Scarpa has been head coach of the men's tennis program for last 35 years and is the nation's third-winningest coach in NCAA Division-I athletics. Scarpa played at Florida State when Gordon Blackwell was president there; seven years later, when Blackwell was president of Furman, he and Lyles Alley persuaded Scarpa to leave his coaching appointment at West Point for Furman. In 1993, the NCAA adopted a dual match scoring system he developed that emphasizes the role of the team as opposed to the individual, and called it the "Scarpa system." The men's tennis team has won 12 conference titles since 1969.

To the tune of the West Point fight song, the lyrics of the Furman fight song were written by Coach Bob King, Sports Publicity Director Fletcher Allen, and the 1963 football team on the bus traveling to face the Citadel. By the time the bus arrived in Charleston, Furman had a fight song to accompany its victory over the Bulldogs. In chapel service the week after the win, the football team, at Dean Ernie Harrill's request, performed the song for the student body. The song caught on quickly, and the university's band continues to play it at football and basketball games.

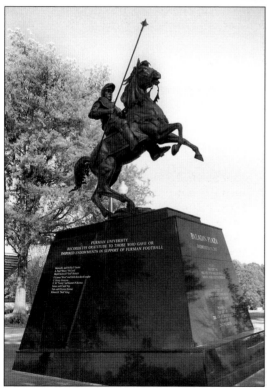

Paladin Plaza, at the entrance to Paladin Stadium, debuted during the 2003 football season. The centerpiece of the plaza is a 17-foot bronze statue of a knight on horseback. Paladin Plaza was made possible in part by Sonny '52 and Keeter Horton, Melvin '52 and Dollie Younts, Irwin and Carol Grotnes Belk, and the L.D. Stewart family. The Paladin is a unifying symbol for all Furman teams and students, as it has been since 1961. Furman's athletics accomplishments are laudable and provide a solid foundation upon which to build a victorious future.

127

BIBLIOGRAPHY

Bainbridge, Judith T. *Academy and College: The History of the Woman's College of Furman University*. Macon, GA: Mercer University Press, 2001.

Cook, Harvey T. *Education in South Carolina under Baptist Control*. Greenville, SC: s. n., 1912.

Daniel, Robert Norman. *Furman University: A History*. Greenville, SC: Furman University, 1951.

Furman University: A Timeless Place. Intro. by David E. Shi. Louisville, KY: Harmony House, 1999.

Glenn, L. Mell. *Bennette Eugene Geer: A Biographical Sketch*. Greenville, SC: Keys Printing Company, 1956.

Huff, Jr., Archie Vernon. *Greenville: The History of the City and County in the South Carolina Piedmont*. Columbia: University of South Carolina Press, 1995.

McGlothlin, William J. *Baptist Beginnings in Education: A History of Furman University*. Nashville, TN: Sunday School Board of the Southern Baptist Convention, 1926.

Owens, Loulie Latimer. *The Family of Richard Furman: An Intimate Story*. Columbia, SC: South Carolina Baptist Historical Society, 1983.

——. *Furman's Fairfield Days, 1837–51*. Winnsboro, SC: s.n., 1949.

Reid, Alfred S. *Furman University: Toward A New Identity*. Durham, NC: Duke University Press, 1976.

Ware, Lowry. *The Daniel Legacy: The Transforming Power of Philanthropy*. Ed. by Marguerite J. Hays. Greenville, SC: University Press, 2000.

UNIVERSITY PUBLICATIONS AND MISCELLANEOUS

Blue and Gold, The *Hornet, Bonhomie*, The *Paladin, Entre Nous, Furman Magazine*

Powers, Jack Arnold. *A History of the Furman University Football Program*. M.A. Thesis: Furman University, 1966.

AUTHOR BIOGRAPHY

Courtney L. Tollison received her B.A. from Furman and her Ph.D. in American history from the University of South Carolina. Under President Shi's direction, she recently developed the Furman University Oral History Project. The *History of Higher Education Annual* published her article, "In Pursuit of Excellence: Desegregation and Southern Baptist Politics at Furman University" in 2004.